letter from the editor

**ONLINE AT:
GOINVADE.COM**

**TWITTER,
FACEBOOK &
INSTAGRAM:
@GOINVADE**

To make dreams a reality, it takes two important things: (1) The confidence to say out loud that you want to create something, despite how difficult it might be, and (2) A relentless dedication to finishing, no matter how long it takes.

This INVADE Zine has been years in the making—it's a culmination of the blood, sweat, and tears of our amazing contributors, editors, and the wonderful supporters who have cheered us along this long journey. This issue is a special tribute to the creative talent in New Orleans and beyond, and marks the beginning of a new chapter for INVADE. As we continue to expand, we will proudly shout: "Create and Conquer!"

In this issue, we spotlight interesting creative projects, including Dreamcar, a new clothing line from designer Lisa Iacono; Sucre, a growing New Orleans-based sweet shop; DVRA, a new online shop featuring handmade purses; and Red Truck Gallery, nestled in the French Quarter of New Orleans.

We also interview a dynamic cross-section of creative talent, including Adam Shepherd, Catherine Markel, Brandan Odums, Christina Flannery, Bonnie Maygarden, Stirling Barrett, and Teresa Bajandas.

We round off the content with photo stories from Azu Roma and Musa Alves, as well as essays on growing up in the '90s and dealing with the distance between our dreams and reality.

With this first issue of the INVADE Zine and the many more to come, my hope is to inspire and encourage you to make your dreams a reality.

Justin

contributors

FOUNDER/PUBLISHER

Justin Shiels
curioustribe.com

EDITOR

Lianna Patch
theenglishmaven.com

CONTRIBUTORS

Tim Meyer

Emily Siegel

Samantha Navarra

Emily Bomersback
emilybomersback.com

Kaitlyn Morris
thekaitlynmorris.blogspot.com

Mary Blessey

Ashley Monaghan

Musa Alves
musaalves.com

Azu Romá
azuroma.com

Marissa Hogan
mediaconnoisseur.webs.com

Rachael Kostelec
therealplandd.tumblr.com

Christina Flannery

Oliver Alexander
olliealexander.com

Rachel Maloney

A MAN, A PLAN, A POP-UP TURNED PERMANENT: RED TRUCK GALLERY

BY: LIANNA PATCH

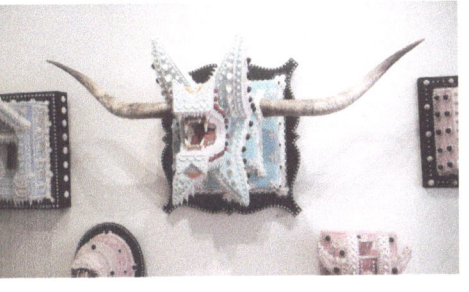

With a "show what we like and fuck the rest" attitude, Red Truck Gallery neatly sidesteps the snobbery associated with art galleries, clearing the way for some seriously interesting artwork.

Run by the cheerfully profane Noah Antieau, Red Truck hosts a collection of jaw-dropping pieces from about 14 different artists. The gallery used to be a traveling pop-up, and established a home at 938 Royal Street during Dirty Linen Night 2013.

"We're lunatics," says Antieau of himself and business partner Nick Sin—who became a part of the pop-up operation when towering Antieau decided the team "needed a midget." The pair also co-owns Lonesome's Pizza in Portland, Oregon, a joint as famous for its personality as its pizza.

Media, subject matter, and execution all vary widely at Red Truck. For instance, you'll see fantastic glass octopus-tentacle chandeliers by Adam Wallacavage hanging in front of eerie nighttime New Orleans scenes by photographer Frank Relle. You'll see tiny, detailed graphite works rendered on matchbook covers by Jason D'Aquino; delicate silver "necklace landscapes" by Susan Elnora; and strange mechanized dioramas by Tom Haney.

You'll see the unholy alliance of epoxy, resin, teeth, and frosting, smashed into joyfully monstrous cake sculptures by Scott Hove. You'll even see playful, detailed fabric paintings from Antieau's mother, artist Chris Roberts-Antieau, who runs her own gallery across the street.

The one thing Red Truck artists have in common is dedication and enthusiasm for their respective crafts. Their creative zeal produces funny, weird, beautiful, creepy, and completely original art—and considering that Antieau was recently tapped to curate an art show whose VIP area he disrupted with a BB gun fight four years ago, the snobby art world is clearly ready for Red Truck.

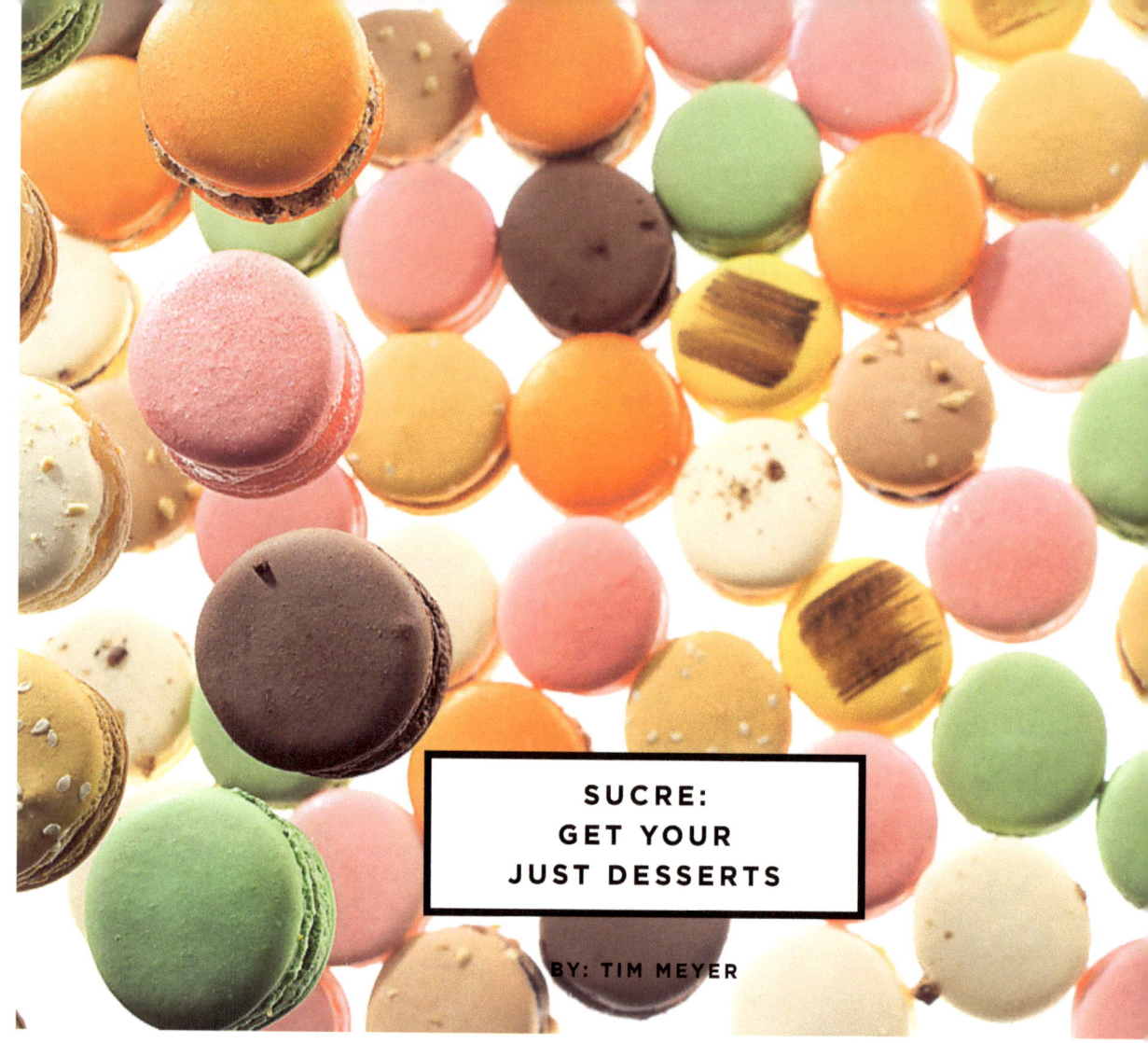

SUCRE: GET YOUR JUST DESSERTS

BY: TIM MEYER

In a perfect world, cheesecake and chocolate sauce would come before cheeseburger and fries. Alas, we do not exist in a perfect world, and perhaps that's why catering entrepreneur Joel Dondis created his own pie-in-the-sky dessert paradise: Sucre. The French word for "sugar," Sucre is a wonderland of gelato, cakes, one-of-a-kind sundaes, chocolate bars, specialty drinks and coffee—everything and anything made with sugar.

But the dessert boutique is much more than just a candy shop. Sucre is where first dates share an Americana Sundae after dinner.

It is where elderly couples pick through an assortment of macaroons after their morning walks. Sucre is the kind of New Orleans spot where confectionary traditions begin. Executive pastry chef Tariq Hanna makes sure that each visit to Sucre—you'll need more than one—is a once-in-a-lifetime treat.

Just don't let all that Sucre has to offer intimidate you, though its prices might. At Sucre, you might have to forgo that extra scoop of gelato—but even if you don't know what macaroons are, you can walk through the glass doors, point to any perfect pastry, and enjoy.

DVRA: PUNCHY PURSES WITH TROPICAL FLAIR

BY: EMILY SIEGEL

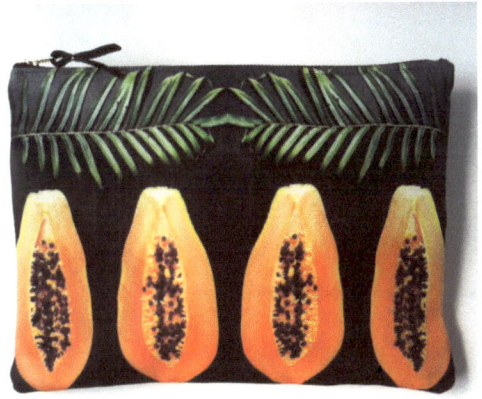
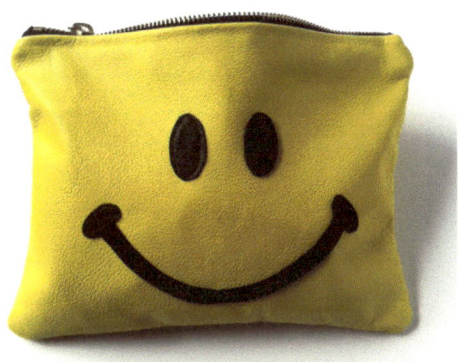
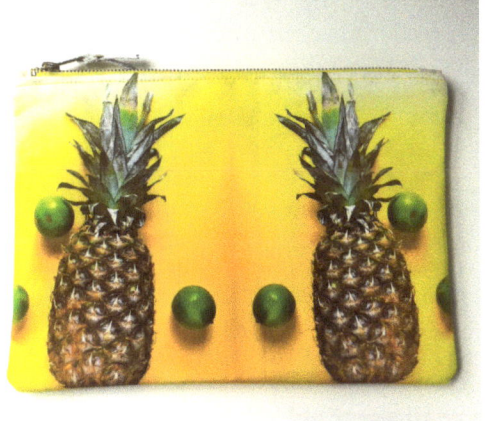
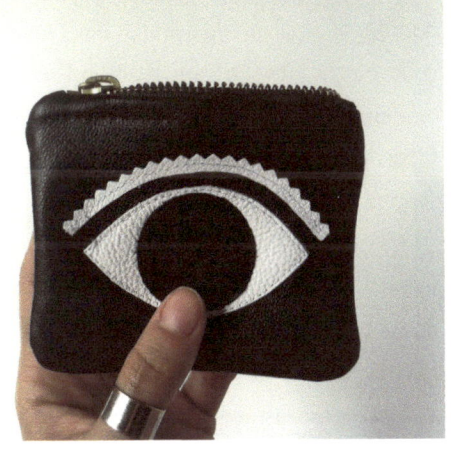

Kathi Keppel's new brand, DVRA, offers versatile bags with bright and unique designs—not to mention they fit your phone, wallet, AND a lip gloss or two. Born in Nicaragua, raised in Berlin, and currently living in New Orleans, Keppel translates an international inspiration into her designs. A leather clutch features hand-sewn cartoon eyes, while a sunglass case is adorned with papayas photographed in the designer's backyard. The name DVRA comes from the Spanish verb *durar*, meaning "to last," and each bag is lovingly handmade in New Orleans.

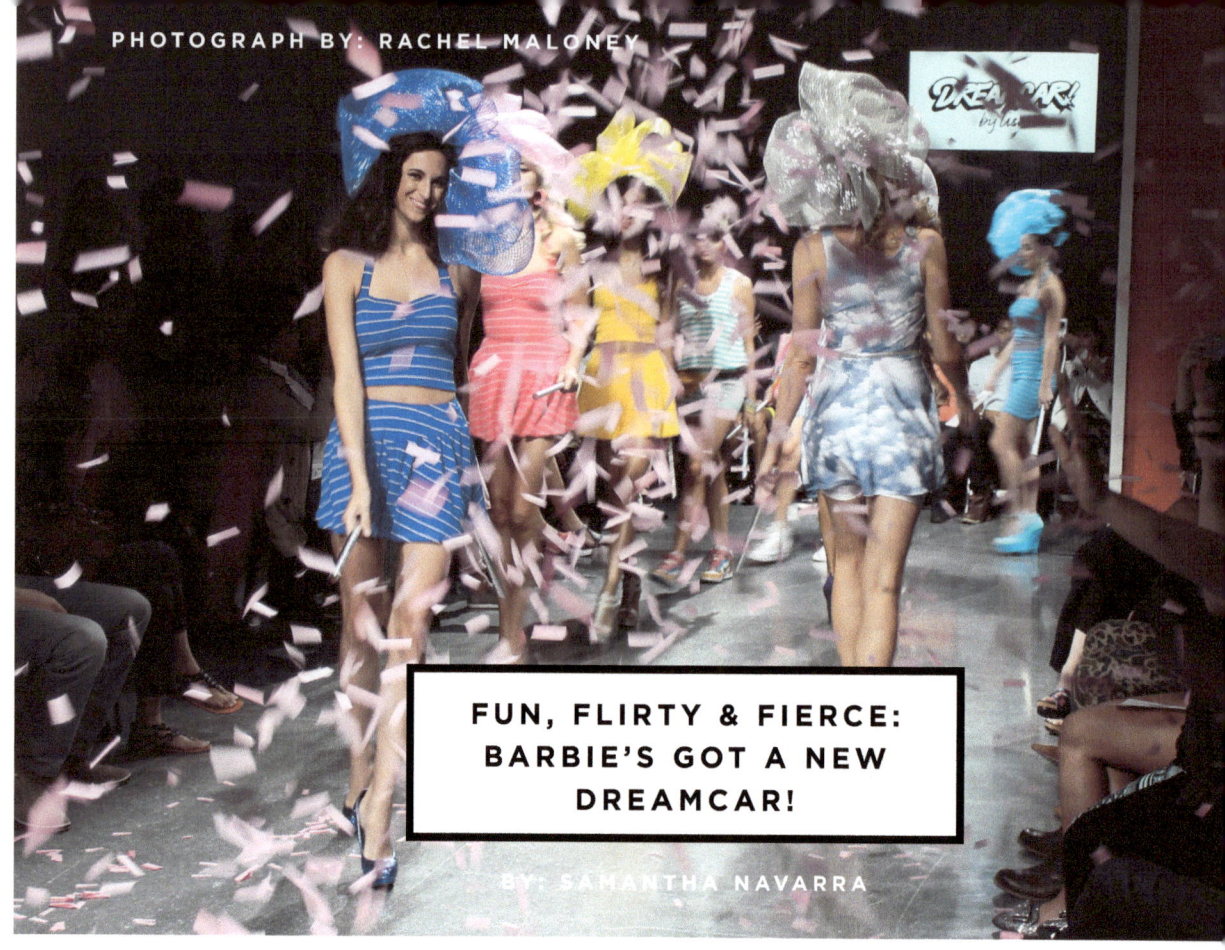

PHOTOGRAPH BY: RACHEL MALONEY

FUN, FLIRTY & FIERCE: BARBIE'S GOT A NEW DREAMCAR!

BY: SAMANTHA NAVARRA

Lisa Iacono, local fashion designer and founder of Nola Sewn, debuted her Dreamcar collection at New Orleans Fashion Week in September, 2013. Not only did her fun and flirty designs turn heads, they brought some serious sass to the catwalk.

Iacono's idea for Dreamcar stemmed from a desire to feel more connected to an audience. Having taken a very serious approach to design for the last few seasons, the designer took a natural swing in the opposite direction with this collection.

Dreamcar speaks to the ultimate party girl: someone who knows how to flirt, has a sense of humor, and isn't afraid to make a statement. The prints are loud and over-the-top in all the right ways. The collection consists of crop tops, high-waisted leggings (constructed to perfection), bandeaus, fun party dresses, and possibly my favorite accessory trend this season: turban headbands.

In describing how her pieces translate to everyday wear, Iacono explains, "Whether it's a gem-printed legging layered under a simple black cotton baby-doll dress, or a money-printed bandeau under a baggy tank with jorts, the Dreamcar girl is excited to add a flash of sass to her ensemble."

She describes the Dreamcar attitude as one that suggests confidence and joy, and most importantly, fun. In her own words: "Life is short. Have fun, laugh, smile, party, dance—that is the Dreamcar mantra." We'll toast to that!

the golden years

BY: RACHAEL KOSTELEC
ILLUSTRATION BY: JUSTIN SHIELS

Being a kid feels like a lifetime ago. In fairness, it has been a long time since the '80s: the awesomely bad decade in which I was born. It was a simpler time, before the Internet, sexting, and that train wreck, Miley Cyrus.

MTV was actually music television then, and the people who performed on it actually wore clothes. Phones didn't come equipped with their own personal assistant; hell, you couldn't even move the phone into the next room for some privacy without tangling the cord!

Then the Internet was invented, and we forgot what a phone was because it wouldn't work while we were connected…but it was so much better, because we could talk to all our friends at the same time with way-cool instant messenger handles like "doglover777" or "cheergirl83".

But then our moms caved and got us our own lines, which was like the best day ever, because instead of chatting online with two friends at the same time, we now had three-way calling. This obviously meant that you could set one friend up to talk smack about another friend while the other was secretly listening, and then your two friends hated each other, but still loved you. Winning!

While most of the things we loved back then have disappeared into our memories (like New Kids on the Block, the Macarena, and Dunkaroos) there are some things that just plain disappeared (like Crystal Pepsi, Judy from "Family Matters," and French cuffs on jeans). But whether they are gone for good or have made a shocking comeback, some pieces of our beloved '80s pop culture have permanently shaped our personalities and taught us valuable life lessons. →

DARIA
MTV ANIMATED SERIES, 1997-2002

While I never could relate to Daria Morgendorffer, the high school outcast, I definitely had a lot in common with her younger sister, Quinn. Quinn taught me that the most important things in life are fashion and boys…and denying your genetic relation to anyone less cool than you. While my sibs were super cool, I do have some Daria-like cousins (who share my last name) whom I am still not willing to claim.

CLUELESS
1995 COMEDY STARRING ALICIA SILVERSTONE

Cher and Dionne were the best role models a 12-year-old girl could ask for, and they like, totally prepared me for high school. From watching them, I learned the importance of being charitable (adopting a tragically unhip girl and giving her a makeover) and the proper way to speak: "as if" I didn't already know. Now I'm 30, and still find myself using Valley-isms in important business meetings. This language has since morphed into what is now commonly known as the "vocal fry": the chosen language of the Kardashian sisterhood. Kim, Kourt, and Khloe also learned to be philanthropic, by entertaining those less fortunate with their stupidity.

RICE KRISPIES TREATS CEREAL
KELLOGG'S BIGGEST MISTAKE

I was deprived of many of the cool cereals as a kid, because my mom always had this weird aversion to "junk" food. How humiliating it was when all I could offer at my slumber parties were Corn Flakes and Raisin Bran, when my friends were serving up deliciousness like Count Chocula. But I would take my healthy (a.k.a. LAME) cereal any day over Rice Krispies Treats Cereal. Rice Krispies cereal: good. Rice Krispies treats: good. Rice Krispies Treats Cereal: soooo NOT good. The white sticky substance used to hold the Krispies clusters together grossed me out before I was even old enough to know what other substance it reminded me of. Since then, I have stuck by the motto, "If it's sticky and it's wet, I gotta jet!"

SAY ANYTHING
1989 ROM-COM STARRING JOHN CUSACK

The epitome of young love. I blame this movie, and this movie alone, for my still being single. I refuse to settle for anything less than some cute hipster guy serenading me in my front yard with his boom box. Will the real Lloyd Dobler please stand up?

POUND PUPPIES
THE ORIGINAL PUPPY MILL

If dogs are man's best friend, these were definitely a kid's best friend. To this day, I would rather hang out with dogs (real or fake) than most people, which is why I credit Pound Puppies with my obsession with dogs. I probably adopted 20 of these pups as a kid, so I don't really understand why it's now unacceptable as an adult to save just as many real dogs from the pound.

SAVED BY THE BELL
HIGH SCHOOL SITCOM ON NBC, 1989-1993

I, like Jessie Spano, get soooo excited when I'm on Adderall…I mean, caffeine pills. SBTB taught us how to do cool dances like "The Sprain" and to start cool bands with our friends (like Hot Sunday and Zack Attack), even if we didn't actually have the musical ability. I still get super pissed that I'm unable to freeze time the way Zack Morris did, but "there's no time…there's just never any time!!!"

BARBIE MAKEUP HEAD COLOR CHANGE 1988 MATTEL TOY

I know I am not the only one who thought this oversized (and decapitated) Barbie head was kinda creepy. And you know you were really disappointed when you finally convinced your mom to buy this for you, only to realize you couldn't put the makeup on yourself. Totally defeats the purpose (but it was cool, because back then, all you needed was a Dr. Pepper Lip Smacker to get ready for Picture Day)! This body-less Barbie taught impressionable little girls like me the importance of accentuating our best features… or how to look like Effie Trinkett from "The Hunger Games".

SALUTE YOUR SHORTS
NICKELODEON COMEDY, 1991-1992

Saturday mornings in front of the TV are probably where I got my inspiration to become such a prankster, but I would never settle for hanging someone's underwear on a flagpole. When it comes to pranks, I prefer fake pregnancy scares. Camp Anawanna also taught me that I never, ever needed to go camping. The one time I tried, things ended up a little more like the next item.

TROOP BEVERLY HILLS
1989 ADVENTURE COMEDY STARRING SHELLEY LONG

"Glamping" is totally more my scene than camping. Beverly Hills Hotel: yes please! Before this movie came out (I was six), I thought Girl Scouts were losers. By age seven, I was begging my mom to let me hustle cookies outside the local K-Mart.

CABOODLES
ENABLING MY OCD SINCE 1986

They say less is more, but not when you're talking about accessorizing your accessories. This high-level, multifunctional organizational accessory was THE status symbol back then. You wouldn't dare be photographed (on Polaroid film, obviously) with the same Caboodle twice. They were ahead of their time with the clear ones—totes NFL-approved.

ONE GIRL: THREE LOOKS

BY: JUSTIN SHIELS

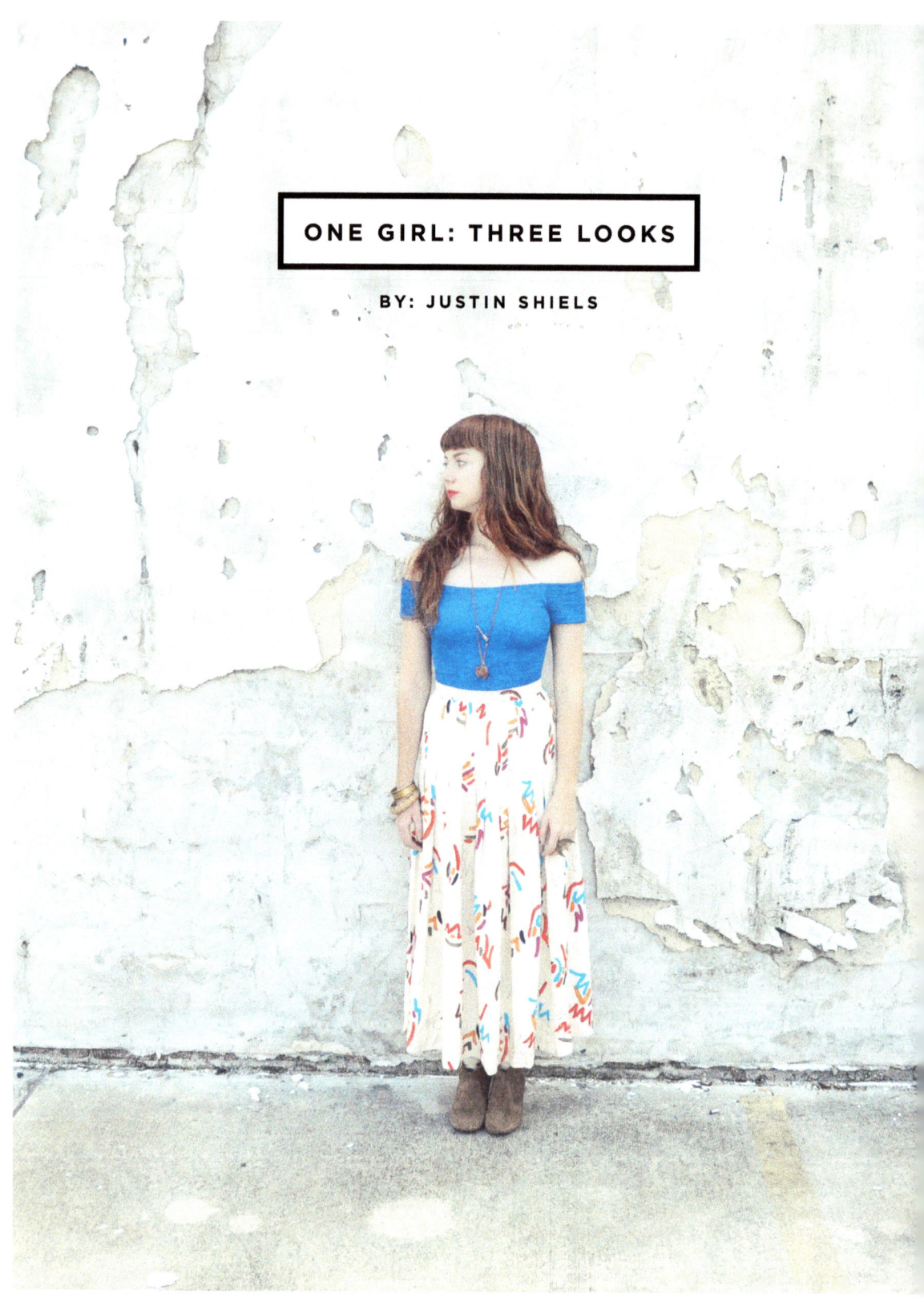

KATHERINE MCGUIRE
WAITRESS
AGE 23

I like to describe my style as being heavily influenced by the early 1920s and 30s, Alphonse Mucha paintings, Stevie Nicks and all things airy and bohemian. I rea[lly] enjoy the sartorial intersection of bohemian and punk, with the variety of colors, prints, and textures.

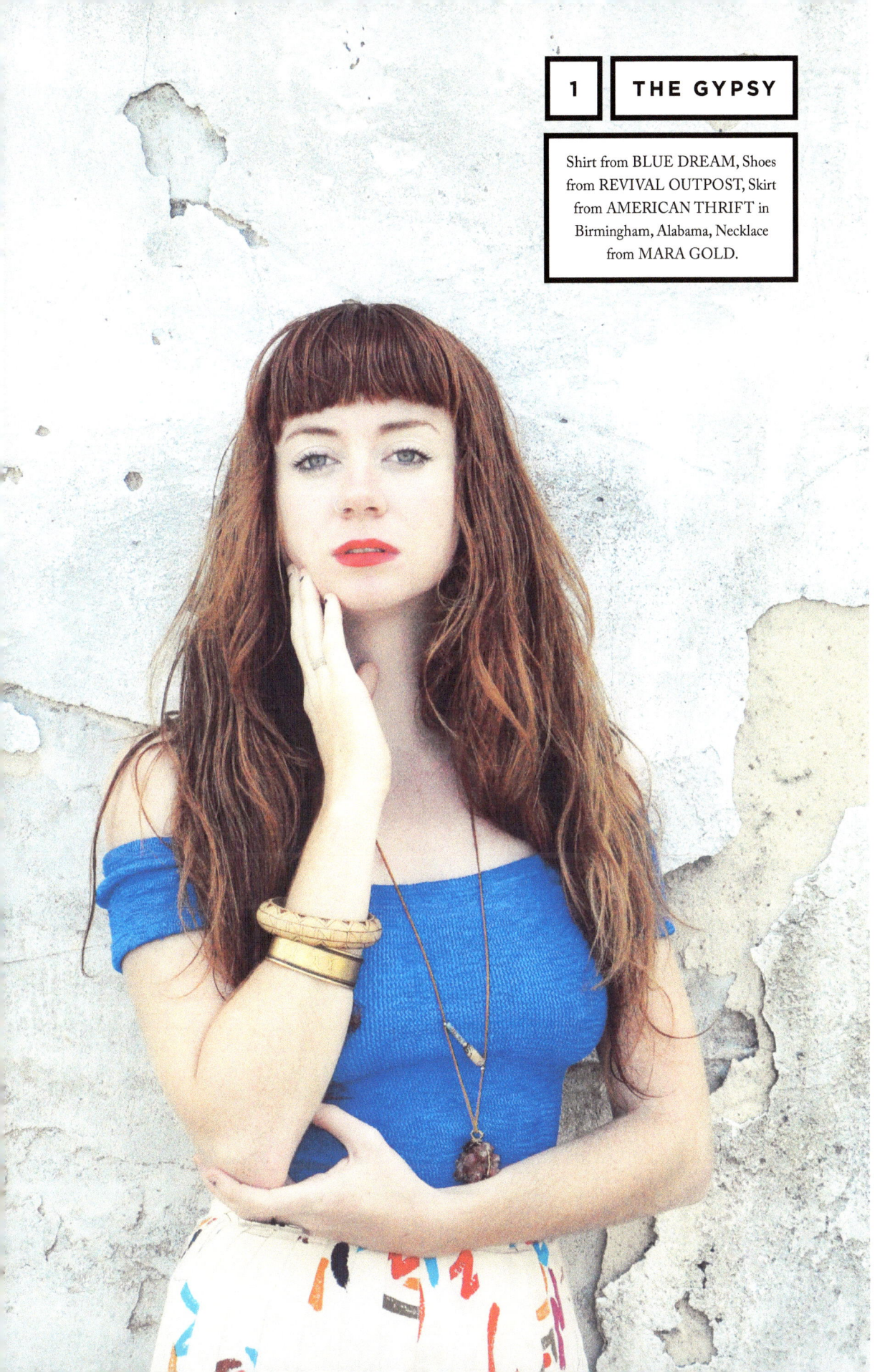

1 THE GYPSY

Shirt from BLUE DREAM, Shoes from REVIVAL OUTPOST, Skirt from AMERICAN THRIFT in Birmingham, Alabama, Necklace from MARA GOLD.

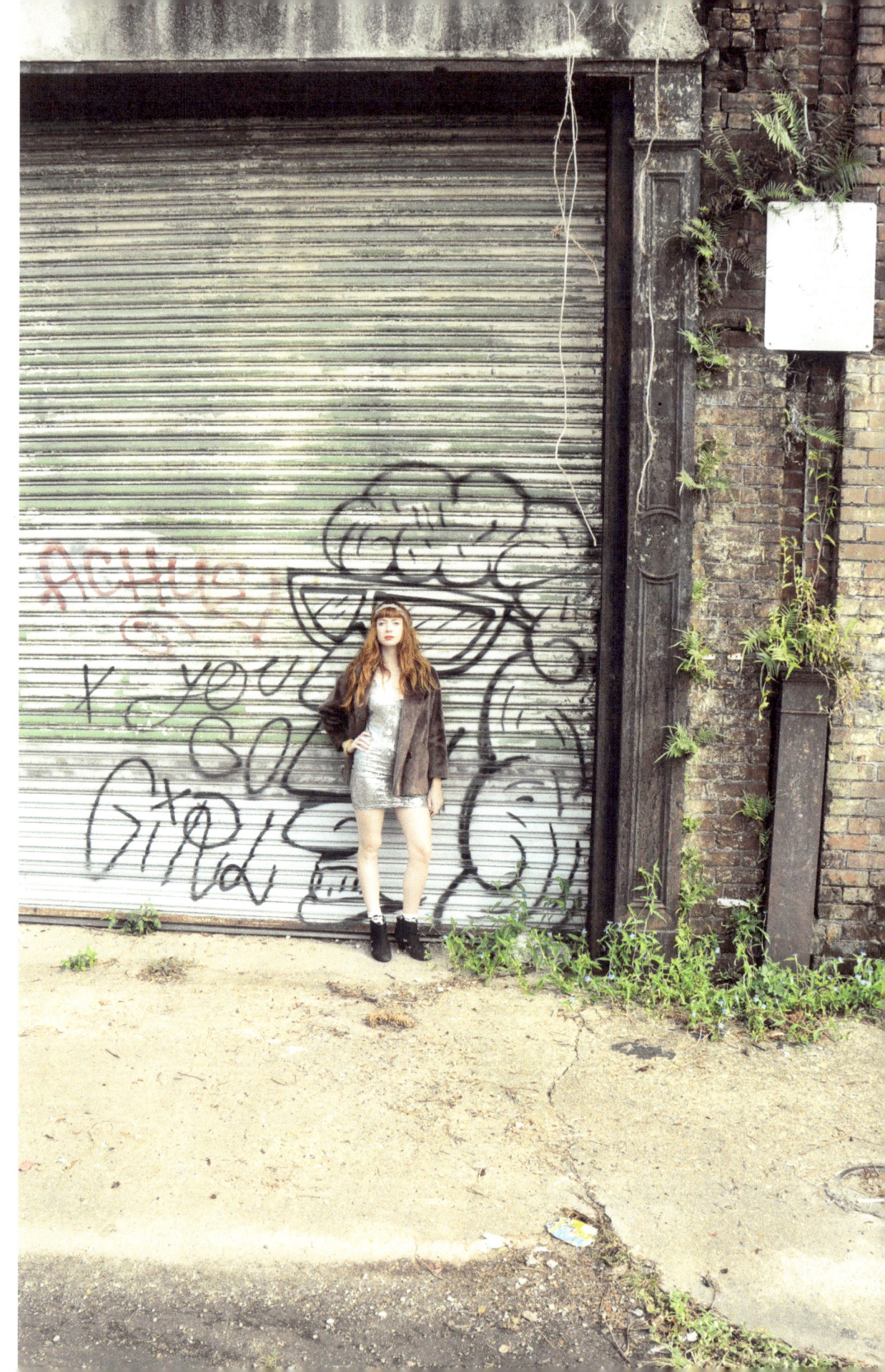

2 | THE GLAM GODDESS

Dress from BUFFALO EXCHANGE, Coat from CREE MCCREE via the PIETY MARKET, Headband—gift, Vintage Shoes from Cleveland, Ohio, Vintage Necklace from thrift store in Budapest

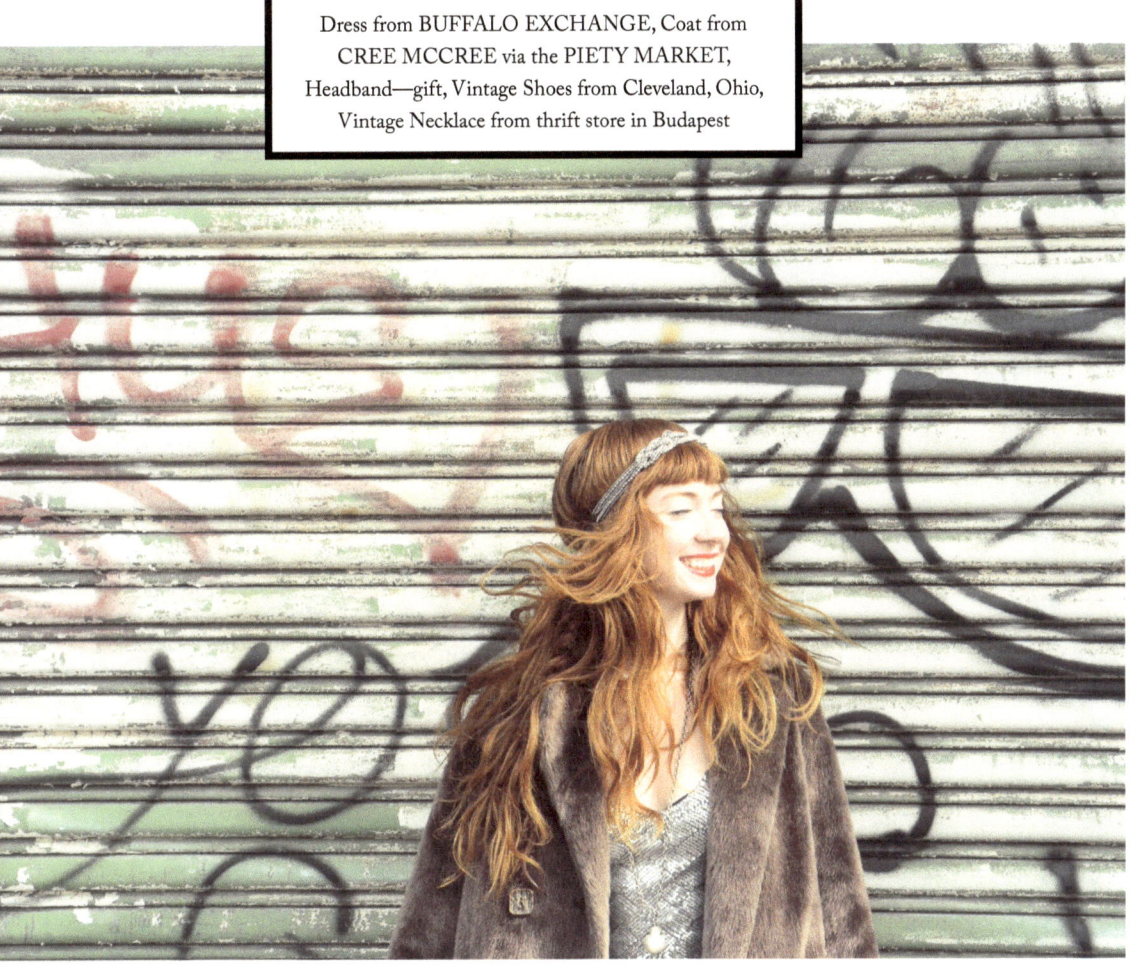

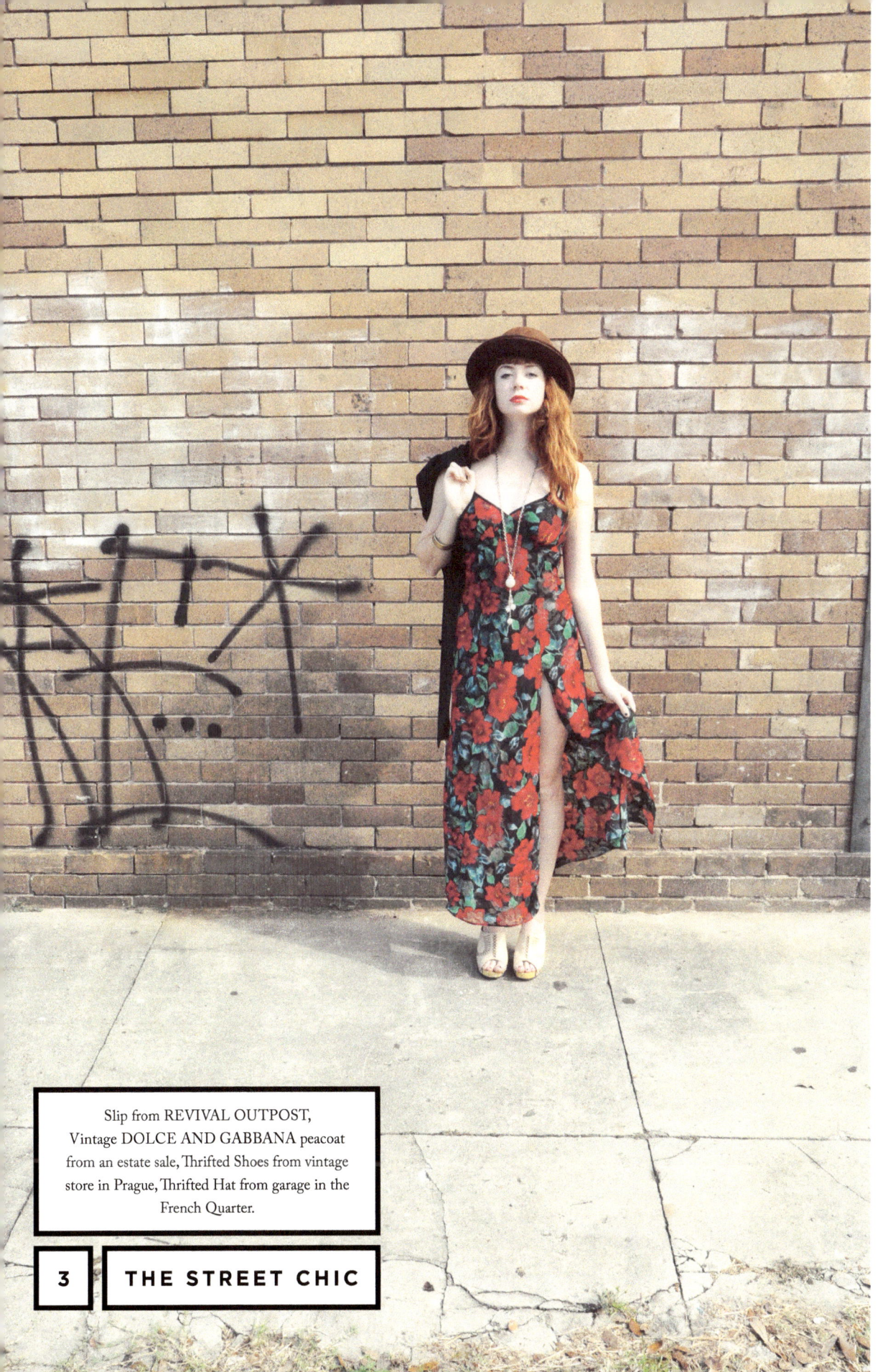

Slip from REVIVAL OUTPOST, Vintage DOLCE AND GABBANA peacoat from an estate sale, Thrifted Shoes from vintage store in Prague, Thrifted Hat from garage in the French Quarter.

3 | THE STREET CHIC

INTERVIEW WITH
ADAM SHEPHERD

BY: EMILY BOMERSBACK
PHOTOGRAPHY BY: OLIVER ALEXANDER

When did you start BOUNCE at Republic?
I started BOUNCE in July of 1999. I went to my first block party in the Marigny, which was amazing. The energy was so raw and real; I think I danced for eight hours straight. They even had infants bouncing. It was wild. At this party, I met New Orleans DJ Rusty Lazer, and told him about the idea of bringing bounce music to a crowd that never gets to see it. Rusty was interested and we started talking/booking artists via Facebook. Big Freedia was the first artist I booked.

Why did you start BOUNCE?
I felt there was a need in New Orleans—for awareness of this genre of music—that wasn't being filled. There are urban bounce nights all over the city that are very "free-for-all," without much organization involved. These shows are cool, but when people want an actual bounce show that is more like a concert, they know they can come to BOUNCE at Republic.

How has the response been to BOUNCE?
The response has been great. We have a crowd dedicated to it, along with a group of regulars, which makes for a great environment. People find the concept funny, I suppose, having this white boy from Kenner throwing these parties, but to me, it's natural. I grew up on bounce music and used to always go to the bounce show at Jazz Fest. I've always been a fan of the music. When writers, actors, producers come to town, they come to our bounce night, so the word is getting out. It has been mentioned on Buzzfeed.com, among other articles.

What is Poorboyz Productions?
Poorboyz Productions is a company that is dedicated to representing, producing, and promoting indie rock, hip-hop, and electronic shows all over New Orleans, both on a local and national level. We primarily work with New Orleans bounce, electronic and hip-hop music; however, we will cater to anyone if we feel the fit is right.

What is your role within Poorboyz Productions?
I am the founder of Poorboyz Productions. I have about 11 promoters I work with.

What was the inspiration behind Poorboyz Productions?
A while back, I ran into an old childhood friend,

Johnny Young. Johnny wanted to make an indie movie about the New Orleans suburb of Kenner, based on a type of urban slang referred to in the area as "Kenner slang," and how this main character had no clue about life outside of this town. I was the main actor in the movie, and got introduced to a good group of friends who I've stayed in touch with, all of whom were in a band called "Poorboyz". Poorboyz Productions was a dedication to Johnny when he moved away, and to everyone involved in that project.

Who are some of the artists that you represent/ produce/promote?
Electronic: I promote and book Sugabear, Ktthulu Prime, Michael Medina, Kid Kamillion, Money P, Unicorn Fukr, DXXXY, Hyphee, to name a few. We book national artists for our "Trap" series, including Salva, UZ, Nadastrom, Gladiator, LoudPvck.

Hip-Hop: I am still very new to the local hip-hop scene. I mainly work with Parallel, formally known as Team Robot. They just put out a new album and I really hope to work with them more in the future. My first nationally booked rapper is ASAP FERG. I've also worked with Knux, which was my first nationally booked show with Republic.

Bounce: Big Freedia, Katey Red, Sissy Nobby, Lucky Lou, Vockah Redu, Hasizzle, Walt Wiggidy, Rusty Lazer, DJ Lil Man, JC Styles.

What is your ultimate goal for Poorboyz Productions?
To produce shows all over the nation.

You've been involved in the New Orleans nightlife scene for quite a while. What/where are your favorite parties in the city?
Wow, great question! Definitely "Obsession". My good friend MUSA has been throwing this party for years; I think it originally started off on Frenchmen Street. "Obsession" was my first real dance party and an introduction to this underground scene. Now it's held at The Saint in the Lower Garden District. "Action Action Reaction" at Circle Bar in Lee Circle [is also a favorite]. This party would get sweaty and people were known to be shirtless. Also, Saturday at the St. Roch Tavern in the St. Roch neighborhood with Rusty Lazer is a great open format for bounce music. It's good raunchy fun.

Who are you listening to right now?
Currently on my playlist is the new MIA album, Kanye West, Juicy J, 2 Chainz, old Lloyd Banks, and Drake. I just can't get enough of the new Drake CD. Also, despite all the criticism, I'd have to add Miley Cyrus to the list as well.

What upcoming bands/ artists do readers need to know about?
Blood Orange, Danny Brown, Hucci, GTA, Death Grips, ASAP Ferg.

You have your hands in several things around the city. What other projects are you involved in?
I'm working with Defend New Orleans to craft a record label. I'm also working on an innovative project with Jaime Garza to design an upscale black/gold masquerade-style party. I'm trying to set up a mini tour with some local big names, and I'm planning on hitting the road with Sissy Nobby. A No Limit Records reunion is in the works for the spring. I also do a monthly "house music" party at the Hi-Ho Lounge.

CATHERINE MARKEL

SERVING THE COMMUNAL WINE TABLE

BY: EMILY BOMERSBACK
PHOTOGRAPHY BY: OLIVER ALEXANDER

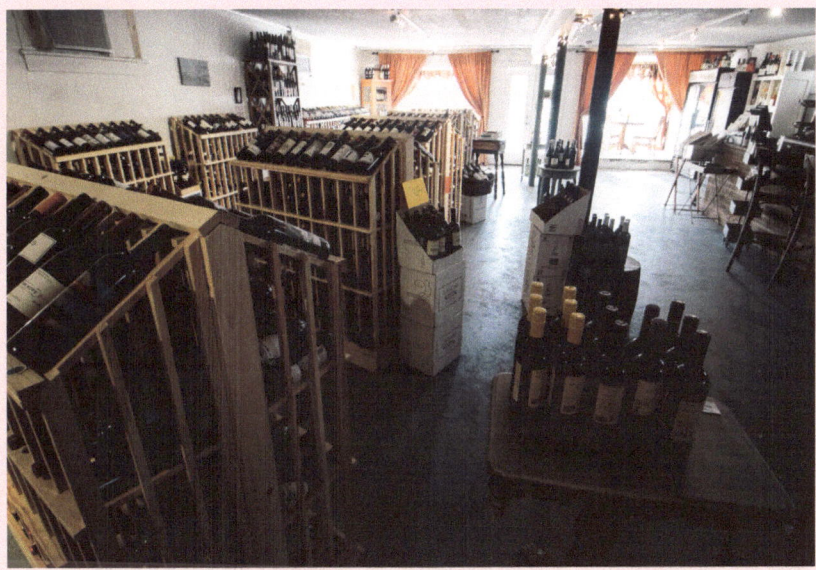

As Catherine Markel gently swirls a glass of red wine and knowledgeably explains its best food pairings to a customer, one would assume that she's been a wino her entire life.

Markel, now the owner of Faubourg Wines, tells a different story. "Truth be told, the only reason I ever started working in the wine industry was because of Hurricane Katrina," she says.

After the storm, Markel found herself without a job and looking for employment.

"There was a bottle shop named Sip that was supposed to open up the week of Katrina on Magazine Street. After the storm, there was nobody around, and I went to speak with the owner to see about helping out with the store," Markel says.

The grateful shop owner immediately accepted Markel's offer.

"Looking back, I really don't know why she hired me," Markel says with a laugh. "I loved drinking wine, but I had no credentials to work there. I'm so grateful she did; I learned so much from that job. It really gave me a start."

While Sip was open for less than two years, it helped form some of the driving principles behind Markel's new venture, Faubourg Wines.

"When Sip closed, it really affected me, and I didn't want the idea of it to die," Markel says. "You could buy a bottle of wine at a reasonable price and sit out on the sidewalk and drink with your friends. New Orleans didn't have many places like that, and I

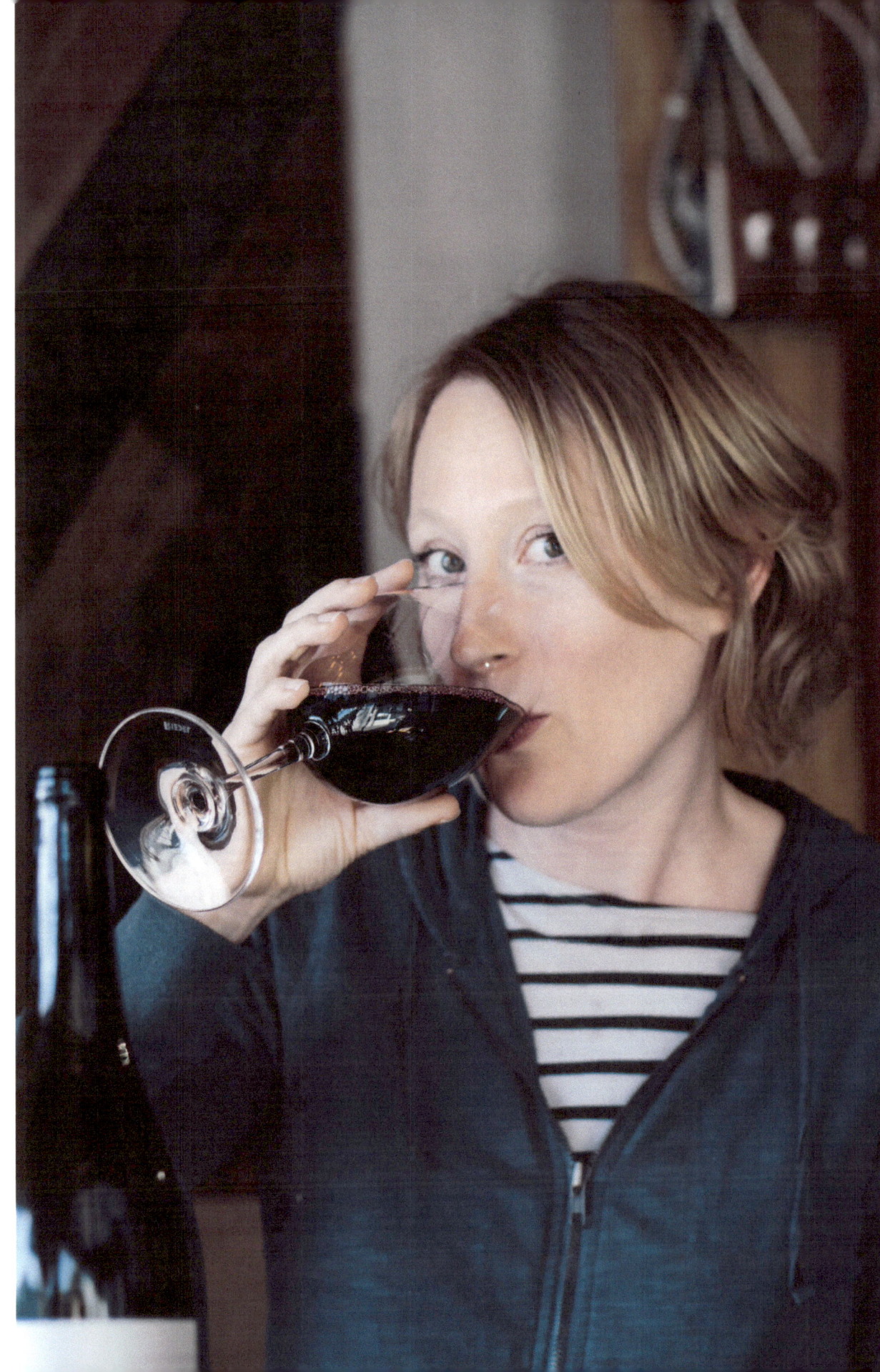

knew that I could do something similar and make it really take off."

Several years later, Markel moved to New Orleans' St. Claude neighborhood and saw a need for this type of communal space.

"There's so little in this neighborhood for retail, making it hard to buy the day-to-day things that you need," Markel explains. "I saw the potential for the St. Claude area and knew that I could get a good deal on rent."

When Markel found a space at 2805 St. Claude Avenue, she realized it was perfect for her dream concept, but started cautiously. "I thought I would rent the space first and then see about getting funding, permits, etc," Markel says. "One thing kept leading to another, and I reached a point where I was just too far down the rabbit hole to turn back."

As Markel laid plans, Faubourg Wines came to life with a force of its own. "There was never this pragmatic conversation with friends and family where I discussed what I was doing or how things were happening; it all just sort of happened," Markel says. "It was really scary, and I didn't know if I could pull it off, but I knew I had to try."

When Markel opened the doors to Faubourg Wines last Thanksgiving, there was much uncertainty and ambivalence about how the local community would embrace the shop. Waiting on permits from the city caused delays, and there was little time to get the word out about the impromptu opening date once everything was cleared.

"We didn't do any advertising. To be honest, no one really should have known that we were even here," Markel laughs, sipping her wine. "When we opened the doors on Thanksgiving, we had no idea if anyone would even show up."

To Markel's surprise, however, people did show up—lots of them—and visitors have continued to arrive over the past year.

"We've been so lucky, and the neighborhood has received us with open arms," Markel says. "This brings me such joy, because this store is for them [the neighborhood]. It was created to be a place where people who live in the area could come and shop, get what they need for every day, or pick up something for a special occasion, expand their wine repertoire, and have fun."

"St. Claude deserves a space like this," Markel says. "Something to start bringing that sense of community back to this area again."

Sitting in Faubourg Wines on a Tuesday evening, hearing the clink of wine glasses at the bar, bottles being discussed in the showroom, and local residents catching up at the tables outside, it's evident that Markel knows how to draw a crowd.

"I loved the idea of having a space where people could run into their neighbors while taking time to slow down and sip a glass of wine," Markel says. "It's such a great feeling and makes for a nice environment when people are just making connections with each other. It really helps to build that sense of community that New Orleans is built upon."

Along with wine tastings, cheese and wine pairings, and food truck visits, Faubourg Wines will soon offer same-day bottle delivery service.

Looking at her shop now, Markel says that the whole process, from business plan to opening day, while not easy, has been worth it.

"If you have that nervous, excited, scared feeling in the pit of your stomach about something, that means you should do it," Markel says. "When I look back at the best things I've done in my life, they were also the scariest. You can't let the anxieties and fears shake you to the point where you give up. Be bold. That's what this shop really represents."

BRANDAN ODUMS

BY: TIM MEYER
PHOTOGRAPHY BY:
OLIVER ALEXANDER

Brandan Odums is tall and broad-shouldered. His long dreadlocks give his T-shirt-and-jeans look an edge, but he is soft-spoken and passionate. He is a teacher, a painter, a filmmaker and, some might say, an activist. Many words describe the 28-year-old artist; just don't call him an artist. It's not that Odums doesn't like the distinction; it's just that he doesn't see himself that way.

"I don't feel comfortable calling myself anything. I just don't like boxing it," says Odums of his diverse resume. "Whatever people call me, I respond to it. I guess what I do echoes what artists do, what filmmakers do, what teachers do. Maybe in some years, I'll realize that's ignorant."

Born in California into a military family, Odums moved back to his parents' native New Orleans during eighth grade and soon found himself wondering what was so bad about the dangerous city from which his mother had tried to shelter Odums and his brothers. Without knowing it, her well-intended protection only fueled Odums' early curiosity about Bourbon Street and certain New Orleans neighborhoods.

"As a developing artist, I explored those places and things I was told not to. I developed my own language and my own style," says Odums. But what Odums also found was that it's easy to get caught up in the slow-paced attitude of New Orleans. That's also what keeps him motivated. "The Big Easy can be like quicksand," he says. "You can sit there and five years can go by and not even notice. That's the curse of it. The gift is that New Orleans is such a well of stimulation. I

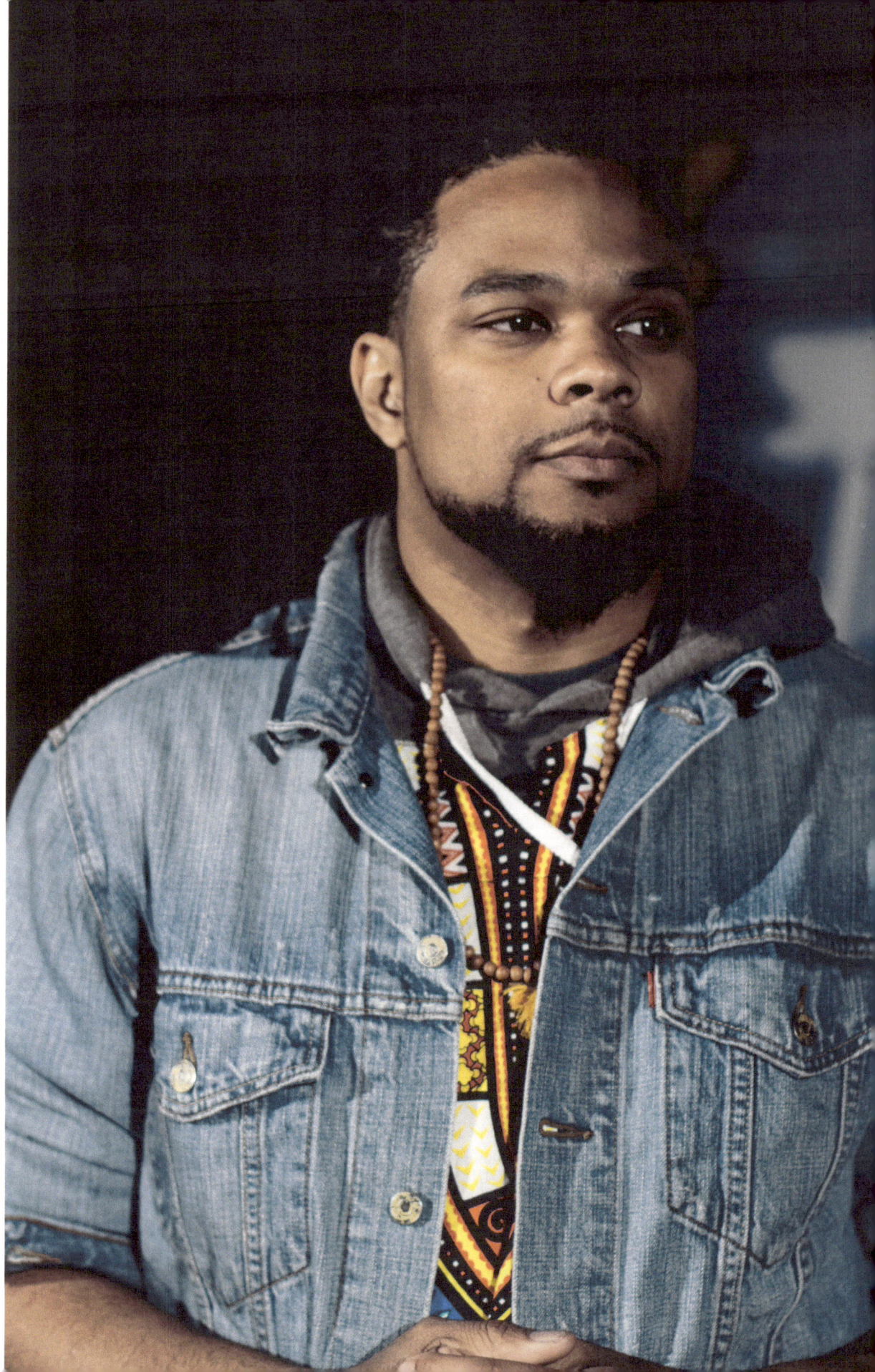

try to focus on that side of it. The kind of work that I do is a conversation with those struggles. I don't think it could have developed in any other city, because my choice of creating is responding to those problems."

Another part of that conversation for Odums is trying to find the balance between doing what he likes to do and making people uncomfortable. Perhaps Odums' most notable work, "Project Be," is the best example of that inner struggle. The growing acceptance of street art in other major cities is still, according to Odums, largely associated with vandalism in New Orleans. Earlier this year, Odums trespassed onto the abandoned ruins of the Florida public housing development and painted a series of murals and quotes depicting influential civil rights activists, including Huey P. Newton, Louisiana native and co-founder of the Black Panthers, gay writer James Baldwin, and jazz singer Nina Simone.

"I was conscious of the fact that I could get in trouble; that at any point someone could see this the wrong way. But one of the biggest blessings is that people got it. Nobody took it as a threat," says Odums. "I realized a long time ago that being an artist is more than just you. There's how people respond to it. As an artist, I have a responsibility to influence people. If I see there's a problem with a property that's been sitting there for eight years, then I'm going to solve it within my own brain. I'm going to make this valuable to me, and it in return make it valuable to someone else; that's a good thing."

Odums actually didn't expect anyone to see the murals. He was just looking for something to do, a space where he could paint what he wanted. He also didn't anticipate the attention the paintings are receiving. Several arts programs, including Prospect New Orleans and the Arts Council of New Orleans, are behind Odums, urging the Housing Authority of New Orleans to open the murals for public viewing as a spotlight on plight and affordable housing. The Florida public housing development has been closed and in decay since Hurricane Katrina hit the Gulf Coast in late 2005.

Although "Project Be" was not intended as a political statement, Odums is not afraid to use his talents to address social issues. As founder of 2Cent Entertainment, described by Odums as a multi-platform content creator, Odums' mission is to bridge the gap between entertainment and education. "It is an art collective of a social enterprise," he says of the organization. "Students spend more time in front of the computer than they do in front of a teacher. We try to create content that promotes education." 2Cent Entertainment creates video parodies and also trains students to use a camera to film their own pieces. "We find talented young artists to use our platform to benefit them," Odums explains.

Even though Odums has dedicated time and effort to finding and educating young artists, the definition of art eludes him. The art world, to Odums, is sometimes claustrophobically bound by the opinions of artists, art experts, and art enthusiasts. Perhaps that is why, in spite of himself, Odums can't commit to the label of "artist". He simply does what he feels is right, and is inspired by what he sees and hears every day—music, gun violence, history, what his grandmother cooks for dinner—without worrying about who will see it or if it would sell. Brandan Odums is just Brandan Odums—observer, creator, human being.

"I still struggle with the definition of art. Around the same time of 'Project Be,' I would go out and see people experiencing it, and in that context of how art was presented, then I went to the Gordon Parks exhibit [at the New Orleans Museum of Art], and the first thing I realize is that it felt like a place I wasn't invited to. It felt empty, quiet, stale. This is not the place I want my art to be," says Odums, though he displayed art at NOMA three separate times as a high school student. "It didn't feel like it was a place that was living. I was taught and trained to believe that this is where the greatest of the greats go, but it felt like a cemetery."

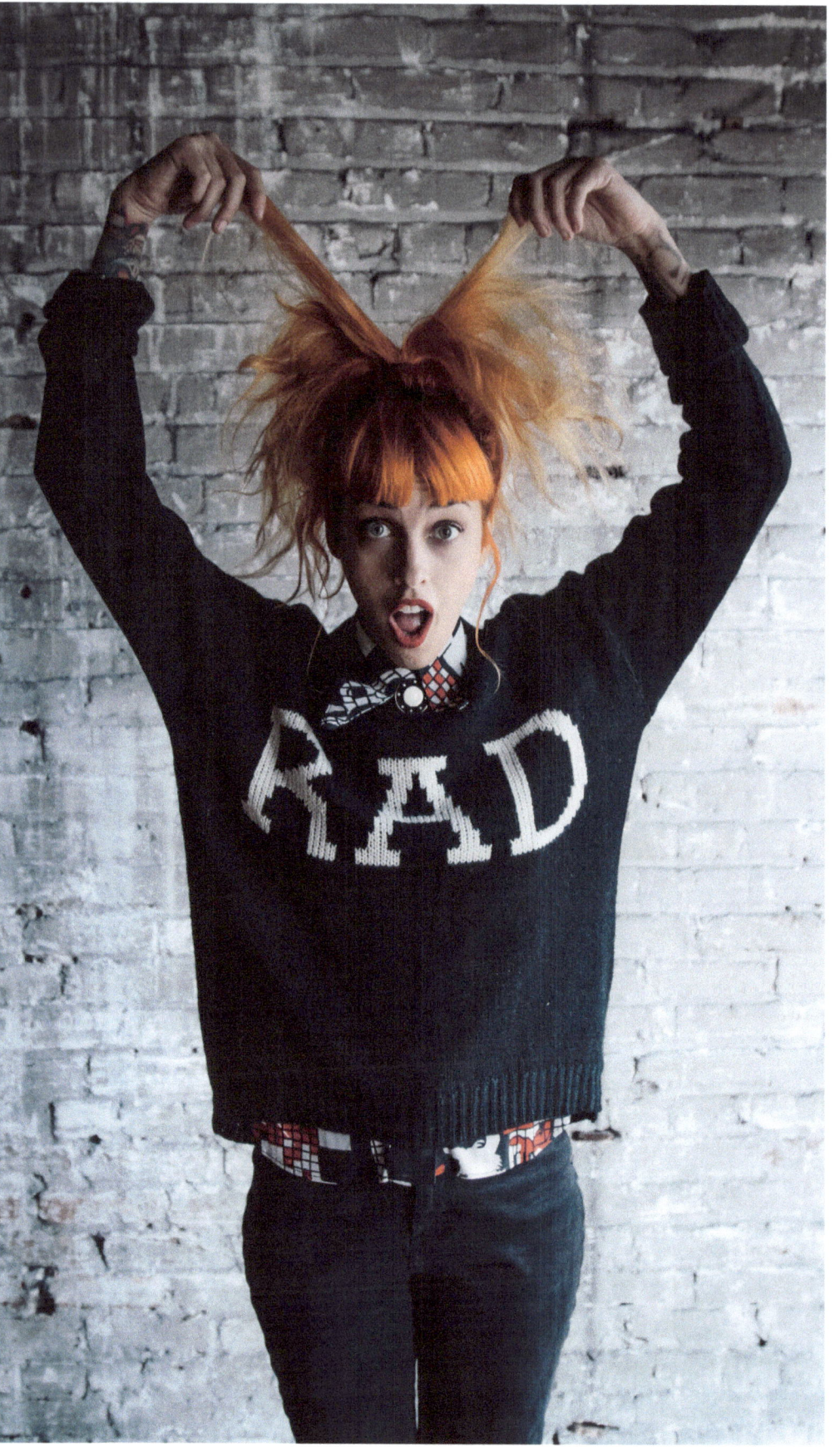

CHRISTINA FLANNERY

LEADER OF THE GIRL GANG

BY: ASHLEY MONAGHAN
PHOTOGRAPHY BY: OLIVER ALEXANDER

Christina Flannery isn't one to blend in with the crowd. Her fiery orange locks would stand out anywhere. She's known for her eclectic style and mad shopping skills, which she honed while opening her store, The Revival Outpost, located at 234 Chartres Street in the French Quarter.

"I was always that kid that got made fun of for wearing hand-me-downs and vintage clothes," Flannery says. "It's just natural. It's my life. It's who I am."

In 2011, Flannery opened The Revival Outpost on Magazine Street, and in January 2013, the store moved to its current location in the French Quarter. "The space is three times the size and just seemed to be a perfect fit for us," says Flannery, who posts regularly on the Revival blog, Facebook, and Instagram.

This clothing mecca is for badass chicks who don't like limiting their style choices. They don't follow trends; they start them. The two-story store is full of vintage steals, modern statement pieces, and a stack of crazy costumes that will transform you from basic bitch to Beyoncé.

Revivals wear something different every day. They mix and match, and pull inspiration from multiple eras. They cultivate the weird and glorify the eccentric. "Revival is a girl gang!" exclaims Flannery.

The enthusiastic shop owner has capitalized on her styling talent over the past two years, working with local designers Amanda DeLeon and Kathleen Tucci, and even styling for *Vogue* online. In addition to working in the costume department on the films "Left Behind" and "Search Party," she's styled for music videos by big-shot directors like James Lees, Tyler Yee, and Ben Reece.

"New Orleans has an allure about it that I've never seen anywhere else," says Flannery. The stylist fell in love with New Orleans before she moved here, but the city was lacking what her store had to offer: great street style, and vintage and modern clothing for all sizes and budgets.

BONNIE MAYGARDEN

VISUAL ARTIST BENDING PERCEPTIONS

BY: KAITLYN MORRIS
PHOTOGRAPHY BY: OLIVER ALEXANDER

Painter Bonnie Maygarden wants viewers to question their perceptions and expectations. The New Orleans-born artist uses paint to create illusions, approaching the medium as "both light and mirror," according to her artist statement.

Although Maygarden works mainly on canvas, her paintings take on a three-dimensional depth, leading viewers to wonder how she was able to create these works without the use of technology.

Maygarden, who trained at the New Orleans Center for Creative Arts (NOCCA), is currently living and working in the city. She credits NOCCA as a motivating environment that pushed her to become serious about painting. "Through working with the teachers there, I learned that becoming an artist was actually possible. It became tangible," she says.

Maygarden, who looks at art "obsessively," is inspired by a long, constantly changing list of artists. Currently, Gerhard Richter, Anish Kapoor, and Katherina Grosse are a few of the artists populating the top of her list, and Maygarden is always searching for new inspiration.

The artist received her bachelor's degree in studio art from Pratt Institute in New York in 2010, and has taken part in several exhibitions since 2006, including shows in New York City, New Orleans, Baton Rouge, and France. Most recently, her works have been featured in her solo exhibition, "Virtuous Reality," at The Front in New Orleans.

While Maygarden pursues a master of fine arts at Tulane University, she is putting together work for a solo show at Tulane's Carroll Gallery in February, and for a show at Staple Goods in April.

She is looking forward to incorporating sculpture and installation in these upcoming shows. "I'm interested in pushing the boundaries of paintings not only as images, but as objects," Maygarden says. "I love to experiment, and it is important to me to keep things challenging and fresh, so I'm always looking for new techniques and materials to play with."

Maygarden's early works contrast greatly with her recent portfolio. Some of her older works include a series of Coke cans drawn with charcoal on toned paper. Another series showcases a set of glittery, gold objects, including a skull, banana, and nail. This series takes items that are commonly overlooked or never considered visually appealing, and makes them beautiful.

"My work is an exploration of materials and forms that attempt to push the boundaries of painting and perception," Maygarden says. "Ultimately, my work serves as a perceptual catalyst that alerts viewers to the experience and expectations of our visual world."

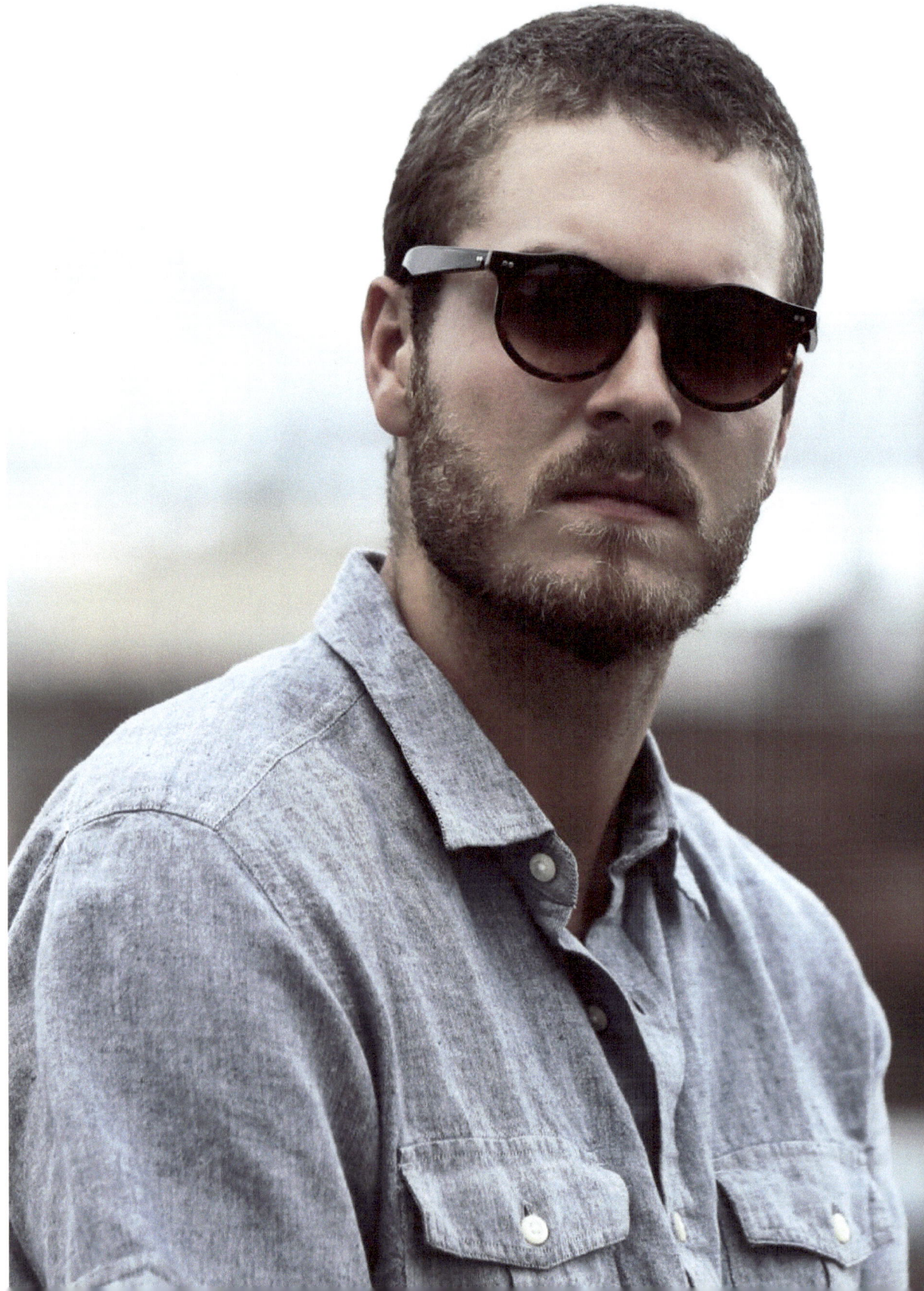

STIRLING BARRETT

THE GLASSES GURU

BY: MARY BLESSEY

New Orleanians know how to party, and the enthusiastic crowd turnout here doesn't just make for a good time; it makes for good business. Pop-up vendors like artist/designer Stirling Barrett are an increasingly common sight at public events and popular streets around town. Walk down Magazine Street or stop by Wednesdays at the Square, and you'll probably spot Barrett—founder of KREWE du optic eyewear—offering his new line of sunglasses from the back of his tricycle.

Born and raised in New Orleans, Barrett began developing his line about a year ago. "Eyewear is one area of the fashion industry that I feel I've always had a very good understanding of, and I think there's a real opportunity for New Orleans to speak out culturally in this area," he says. The brand now offers three distinct frames whose names reflect the city that inspired them: "Toulouse," "Calli-ope," and "The Fly." By Christmas, KREWE is set to launch four more frames, totaling seven styles in 30 colors.

The line is versatile and deliberately understated. Barrett wants his sunglasses to complement any preexisting wardrobe. "We want to make frames that represent who you already are, not ones that overwhelm your look," he says. These unisex frames are crafted from high-quality materials and offer Barrett's personal take on familiar styles, such as the wayfarer or the clubmaster. "From the beginning, my idea has always been to take the classic stylings, update them, and make them out of fun and funky acetates," he explains.

The young entrepreneur is excited to see the local fashion industry growing in New Orleans. "We're finally getting recognition for our unique style here. It's not what you'll find in New York or LA—it's definitely our own," Barrett says, adding, "I mean, hell, if Dallas can be considered a style city, I know New Orleans can."

The name "KREWE du optic" is, of course, a reference to local Carnival culture. It also represents the coterie of local artists and designers with whom Barrett collaborates for the line. For instance, he teamed up with Tchoup Industries to fashion a special "Hubig's Case" to fit his frames. He collaborated with New Orleans artist Ben Bullins to build the "KREWE Cart" tricycle entirely from recycled materials, including part of an old piano. Local musicians Meschiya Lake and Luke Winslow King modeled the line for KREWE's website.

"KREWE can mean a lot of things," Barrett explains. "Most of all, I see it as a likeminded group of all the people who represent our vision."

TERESA BAJANDAS

UPPER EAST SIDE SWEATSHOP TO *NEW YORK* MAGAZINE COVER

BY: EMILY BOMERSBACK
PHOTOGRAPHY BY: STEPHAN GÖTTLICHER

THE BEGINNING OF A BLOSSOMING CAREER

Growing up in San Juan, Puerto Rico, lifelong creative Teresa Bajandas had design in her blood.

"Fashion design was what I wanted to do. Ever since I was a kid, it's what I knew I would be," says Bajandas, a fashion and interior designer. "I took charge in my own bedroom at home—painted the furniture, the drapes, prepared my outfits for the weekend. It was all about making something special and making my own look."

Although her roots were in Puerto Rico, Bajandas knew that if she wanted to get competitive in the fashion design industry, New York City was where she needed to be. After being accepted into the Pratt Institute, Bajandas moved to New York to begin her career.

Bajandas attended Pratt for four years, but her third year proved to be the most exciting when she was offered the opportunity to move to Florence, Italy and apprentice with Emilio Pucci, a renowned Italian fashion designer.

"It was Florence in the 1970s…it was absolutely beautiful," Bajandas remembers. "Florence has this timeless beauty that's difficult to find in other parts of the world. It's very inspiring. It was like living in a museum."

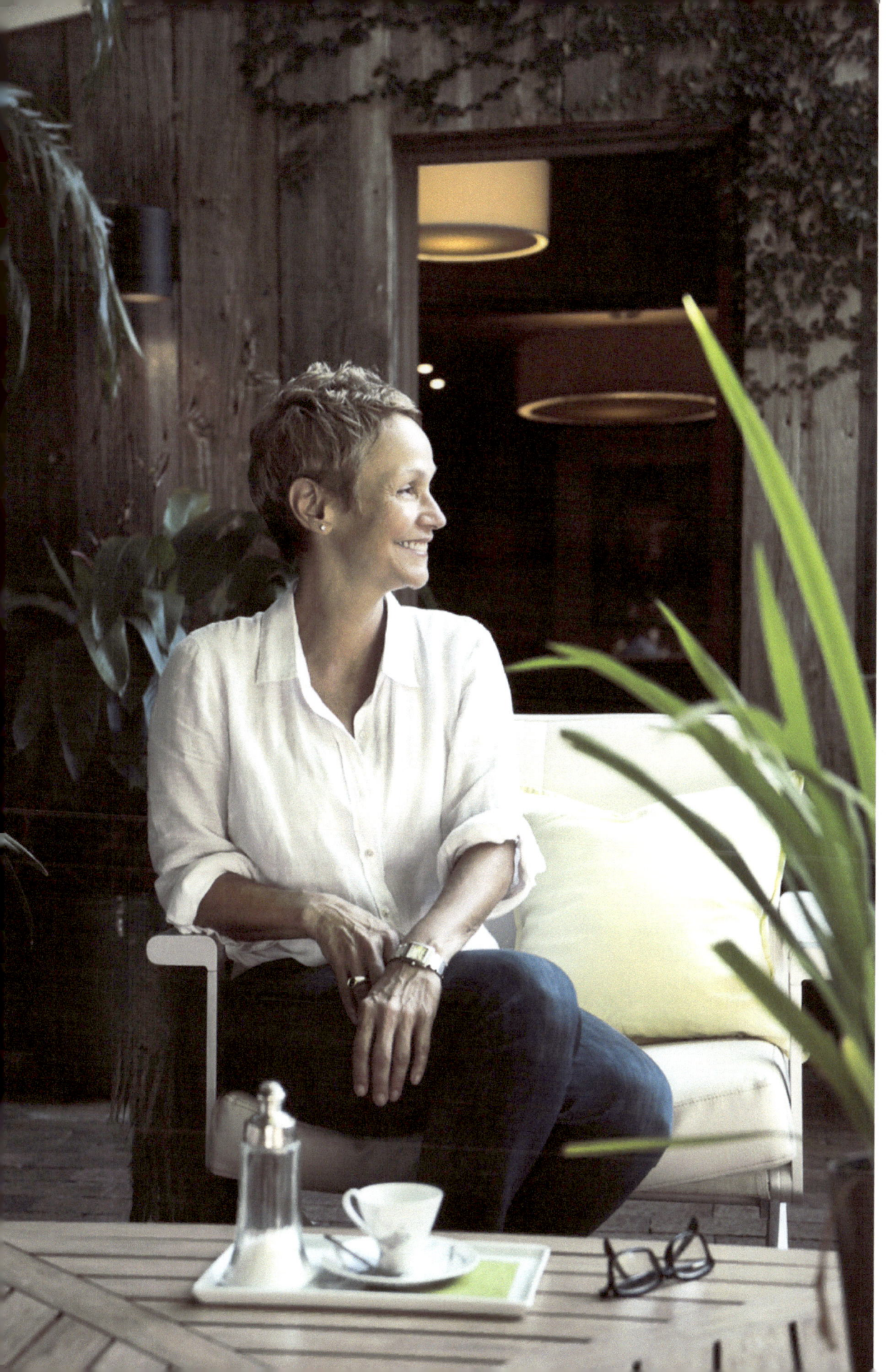

Despite all the inspiration and experience that Bajandas cultivated while working in Florence, when she was offered a job, she politely declined to stay.

"At that time, there was no Internet or easily accessible ways to stay in touch with people in other parts of the world," Bajandas says. "As much as I appreciated and enjoyed my experience in Florence, I missed the energy of living in New York City, and felt that I had to go back."

Bajandas returned to New York, and upon graduation, got a job working with fashion designer Roy Halston Frowick, referred to simply as Halston. The designer was known for his influence on the '70s discotheque fashion scene, and Bajandas soon entered the same circles. "I got invited to his parties, and there were always interesting people there," she remembers. "It was during the days when Studio 54 was at its peak. Those were crazy and interesting times."

DIVING INTO LOVE AND WORK

Working with Halston, Bajandas' career path was progressing—but when she met her future husband Roberto Lugo in an airport by happenstance, everything changed. Lugo was a psychology major at the New School in New York City. Unhappy with his major and having captured Bajandas' interest, he saw his partner's design work and became increasingly interested. "I told him, if you want to make money, make money with me," Bajandas says.

With those simple words, Bajandas and Lugo laid the foundation for their first business venture together.

Bajandas was creating a line of linen blouses and shirts at the time, and Lugo took the shirts over to one of Bajandas' friends, an editor for a fashion magazine.

"Next thing I know, Roberto storms into the front door of the apartment, saying, 'He loves them, he loves them!'" Bajandas recalls. The editor had ordered five to six dozen shirts, to which Bajandas responded, "Are you crazy? We don't even have a storefront or operation in place to produce these!"

Never shying away from an opportunity, Bajandas and Lugo rented sewing machines, turned their apartment into a work space, and hired workers to sew and make the garments.

"We had our own sweat shop in the Upper East Side," Bajandas says.

At night, Bajandas and Lugo would roll out the fabric across the floor and prep it for the next day's workers to sew. This apartment-style operation lasted a couple of months, until the landlord kicked the couple out, stating that the space was meant to be a dwelling, not a clothing boutique.

Bajandas and Romero found a space in Tribeca. They lived and worked out of this space for five years. It was here that Bajandas' designs progressed from apartment production to her first big break: placement in a boutique store in SoHo.

"Linda Robin's West Broadway storefront, called Linda Hopp, on the main drag in New York City's fashion capitol of SoHo, was absolutely our first big break," Bajandas says. "That really changed everything."

A scout from *New York* magazine came into the boutique and picked up one of Bajandas' blouses, and the blouse was photographed and ended up on the cover of the magazine.

"After being on the cover of *New York* magazine, everything changed," Bajandas said. "All of a sudden, every other month, *GQ*, *Daily News Record*, etc. would pick up something that we did and write about it in their magazine."

Bajandas and Lugo had the company for five years, selling garments to high-end boutiques like Barneys and Bergdorf Goodman.

With all their success, however, Bajandas and Lugo still felt like they needed a back-up plan.

"With fashion, you absolutely need a back-up plan, a reserve of money," Bajandas says. "We were self-financed, which is difficult, and felt we needed to start something new to keep the momentum going."

"We had a friend who was a manager for a cocktail lounge in New York and wanted the girls to wear something that was a uniform, but didn't look like a uniform. I asked Robert, and he said, 'Anything for cash!'" Bajandas recalls with a grin.

Bajandas and Lugo made their first foray into the uniform design business, a trade they refer to as "apparel programs," and immediately realized its potential.

"When you're doing a uniform program, it's an extension of the brand, and should reflect the interiors, the style, and the whole philosophy of the company. This is what apparel programs are all about," Bajandas explains. "We really like the idea of having the same fabric and transforming it into different looks and uses while maintaining continuity. It was the exact contrary of throwing everything out every season, which is how the fashion industry is framed."

Bajandas and Lugo have since designed apparel programs for Hilton International, Mandarin Oriental Hotel Group, and The Peninsula Hotels, along with the Mirage and the Bellagio in Las Vegas.

CROSSING BORDERS

Bajandas moved to Chicago to continue working on the apparel programs, and there found her love for a new path. She began studying interior design at the Harrington College of Design.

During her education at Harrington, Bajandas interned with RTKL, a global creative services firm in Miami. This lasted until Bajandas' husband Robert was transferred to Hong Kong for his work, and the couple moved to Asia for two years.

"I loved Hong Kong; it was a sabbatical of sorts," Bajandas says. "It was, however, difficult to get into the business there as a newcomer, and I knew once we returned to the States, we had to start strong again."

Bajandas kept true to her promise, and when she and her husband returned to the United States, they established their own company: Global Hotel Resources. With this new venture, the couple partnered with wood designer and manufacturer Oscar Ono, and became the exclusive United States distributor for Ono's products.

"We opened a showroom in our backyard for Oscar's wood and had it for three years," Bajandas says. "The showroom was so successful, and everything went so well that we decided to open in another location that was more visible and accessible—more of a business location."

Global Hotel Resources had its grand opening in a new location in Miami's Iron Side District on October 24, 2013. "We knew it was time to take the next step, and this was it," Bajandas says. "Having the showroom where it is now allows people just to walk in, take a look around, and cultivate new ideas for their own homes or businesses. This is very exciting!"

With so many shifting parts of her business, Bajandas always keeps her overall design goals in mind.

"No matter what type of design project Global Hotel Resources is working on, there are always issues that need to be solved. If it was perfect, it wouldn't need to be designed," Bajandas says with a laugh. "Our goal is to make people happy by respecting the people who are going to be utilizing the space, and discovering the best approach for their specific situation. When you're in the space, you want everyone to feel comfortable, like they belong there. That's what keeps people coming back."

Bajandas is inundated by possibilities for future design work.

"Right now we're in the midst of a really exciting time with our new showroom just opening up and getting an increasing number of interior design requests, which I love," Bajandas said. "If we can juggle the house, the design space, and our social media campaigns while keeping everything fresh, current, and growing, I'll be pleased. Keeping tabs on Sammy, our dog, is important too," Bajandas says with a smile. "I guess that's the beauty of design: it never ends."

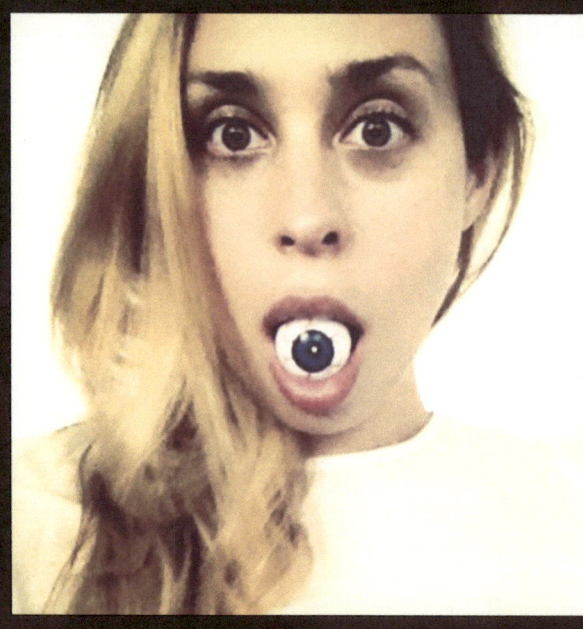

PHOTO DIARY: MUSA

Musa, born and raised in New Orleans, is a self-proclaimed Brazilian/redneck half-breed. She began taking photos at the age of 14. The following photos were chosen from collections taken over the past 10 years.

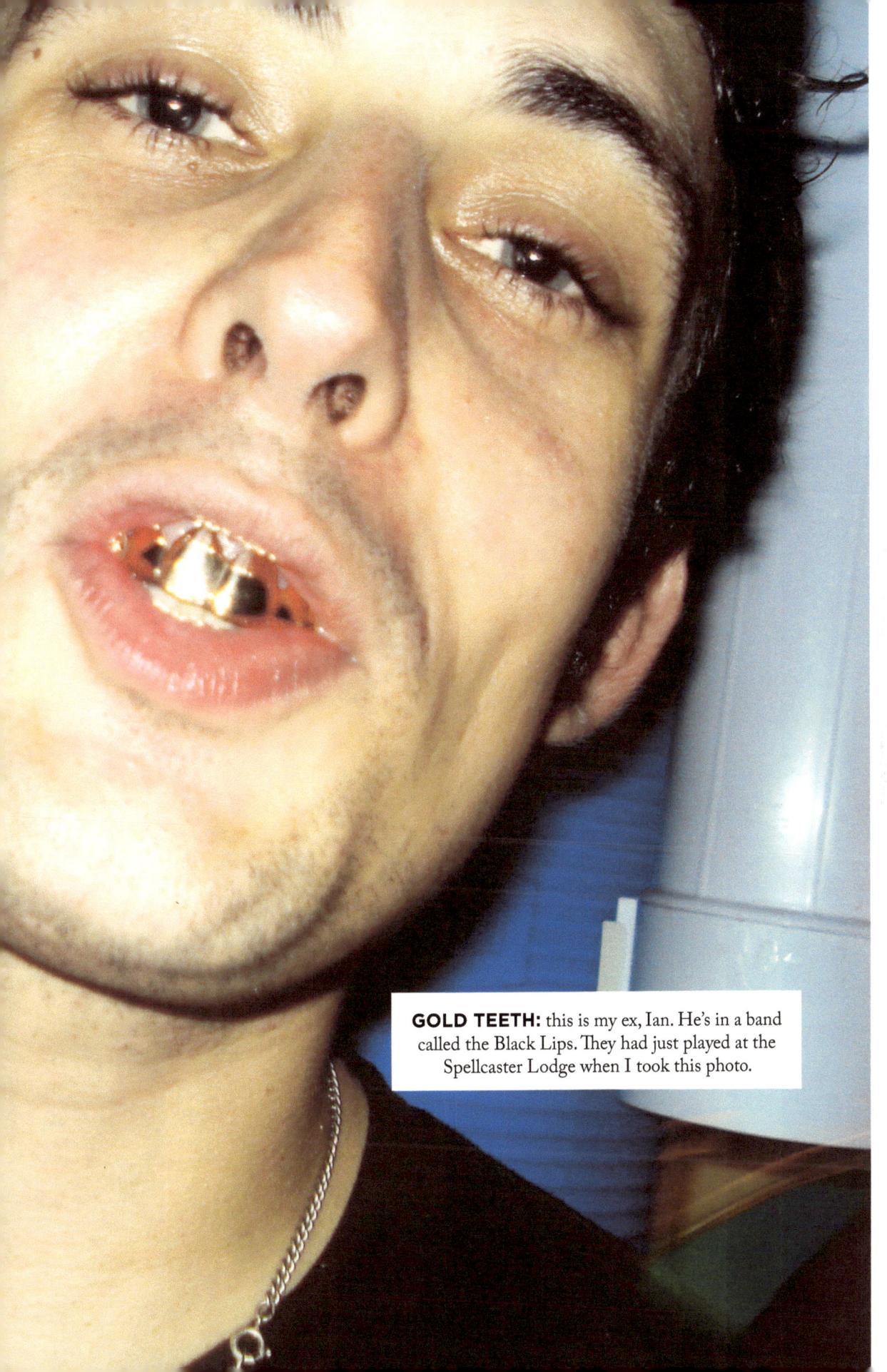

GOLD TEETH: this is my ex, Ian. He's in a band called the Black Lips. They had just played at the Spellcaster Lodge when I took this photo.

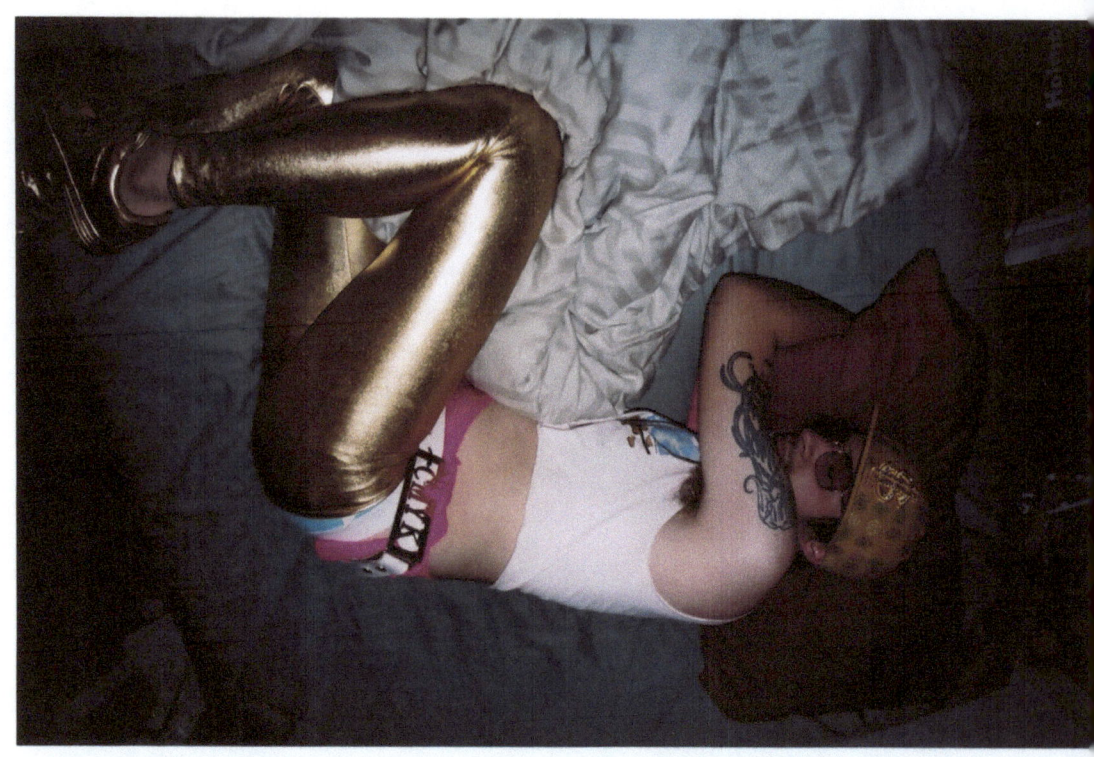

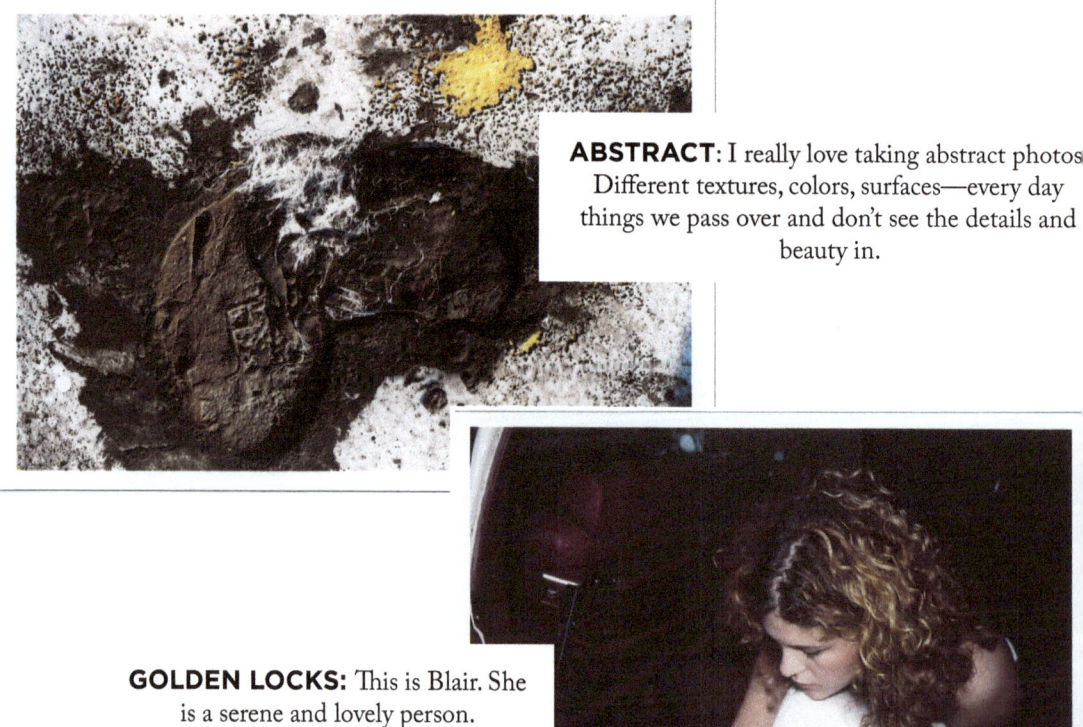

ABSTRACT: I really love taking abstract photos. Different textures, colors, surfaces—every day things we pass over and don't see the details and beauty in.

GOLDEN LOCKS: This is Blair. She is a serene and lovely person.

MOTHER MARY: This is my dear friend, John. He was heavy into drugs when this photo was taken at his mother's house. He's now in Africa working as a missionary for the next two years.

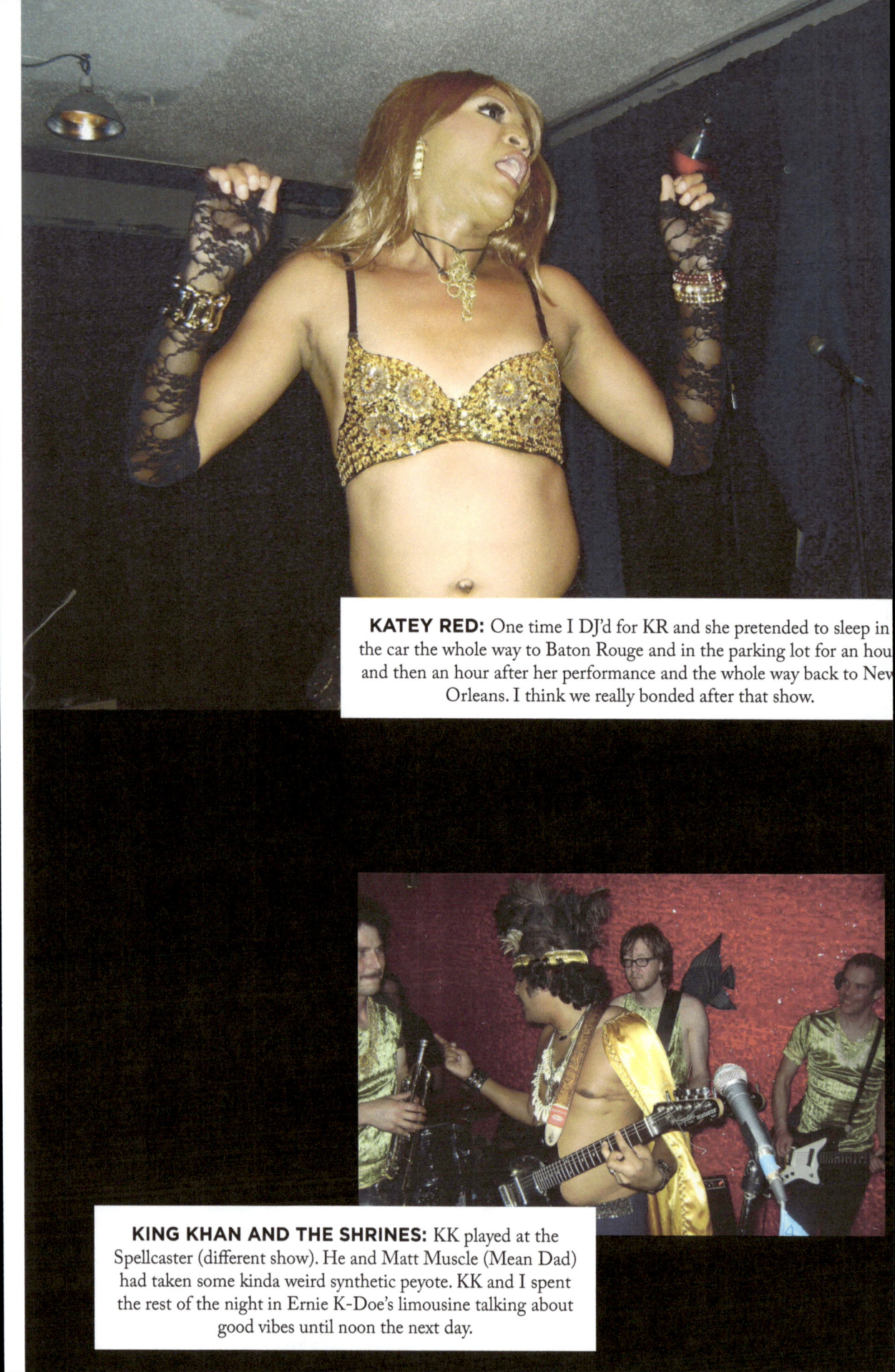

KATEY RED: One time I DJ'd for KR and she pretended to sleep in the car the whole way to Baton Rouge and in the parking lot for an hour and then an hour after her performance and the whole way back to New Orleans. I think we really bonded after that show.

KING KHAN AND THE SHRINES: KK played at the Spellcaster (different show). He and Matt Muscle (Mean Dad) had taken some kinda weird synthetic peyote. KK and I spent the rest of the night in Ernie K-Doe's limousine talking about good vibes until noon the next day.

TIGER PRINT: I can't really say what this picture is about.

Gold Rush

MODELS: ARIELLE, ANNA, AND ALEX
PHOTOGRAPHY BY: CHRISTINA FLANNERY
SPECIAL THANKS TO REVIVAL OUTPOST FOR PROVIDING CLOTHING

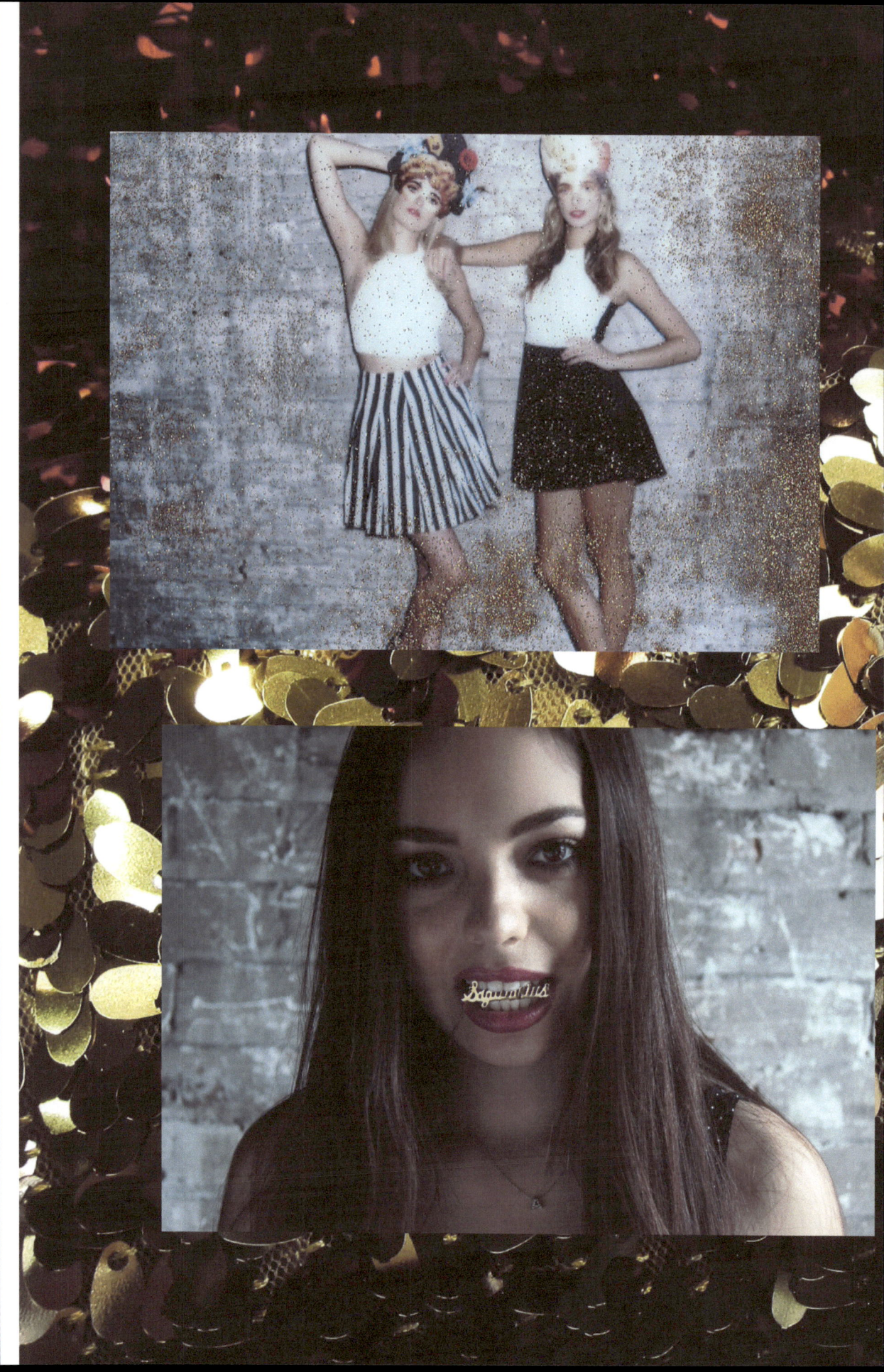

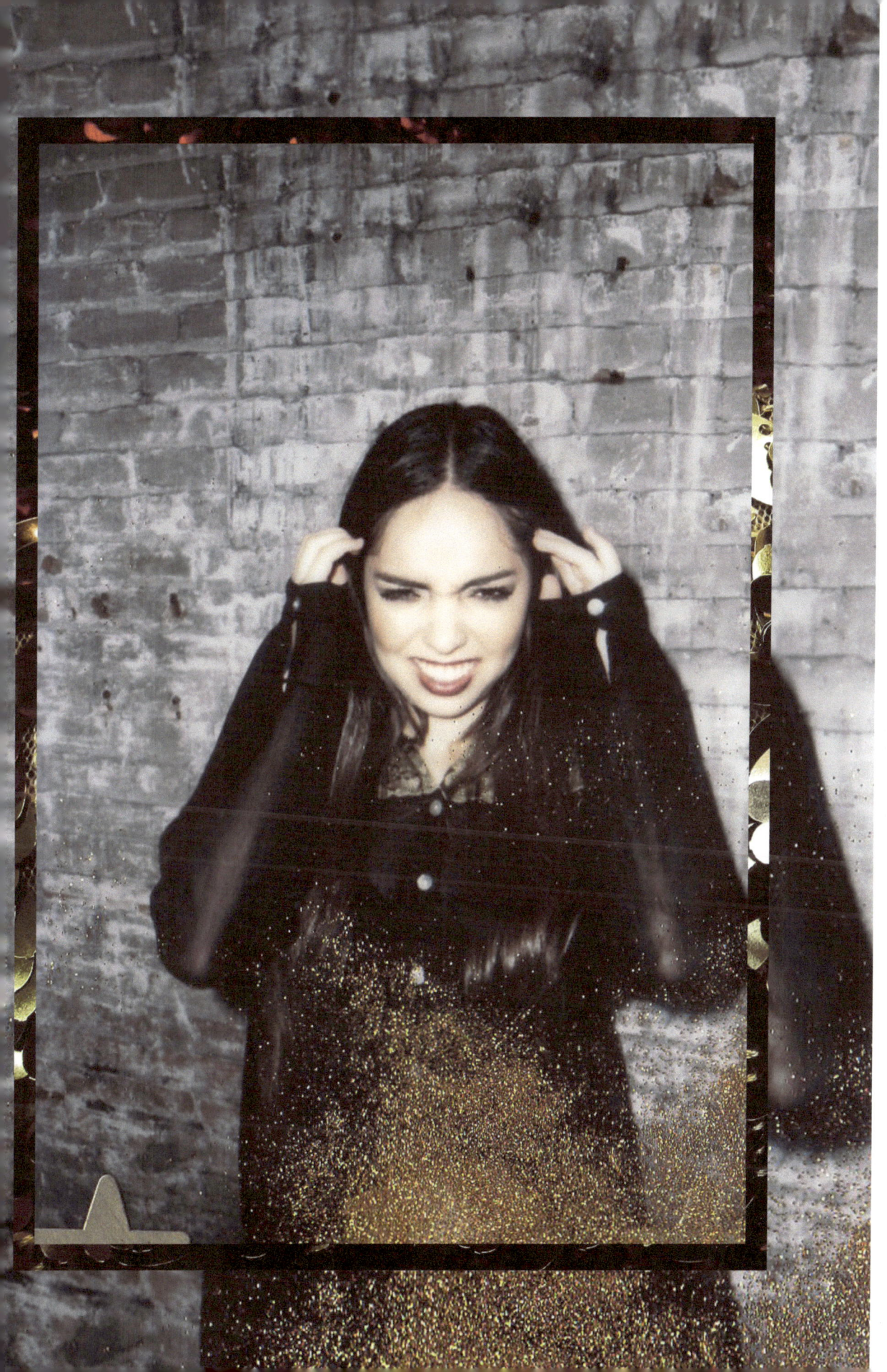

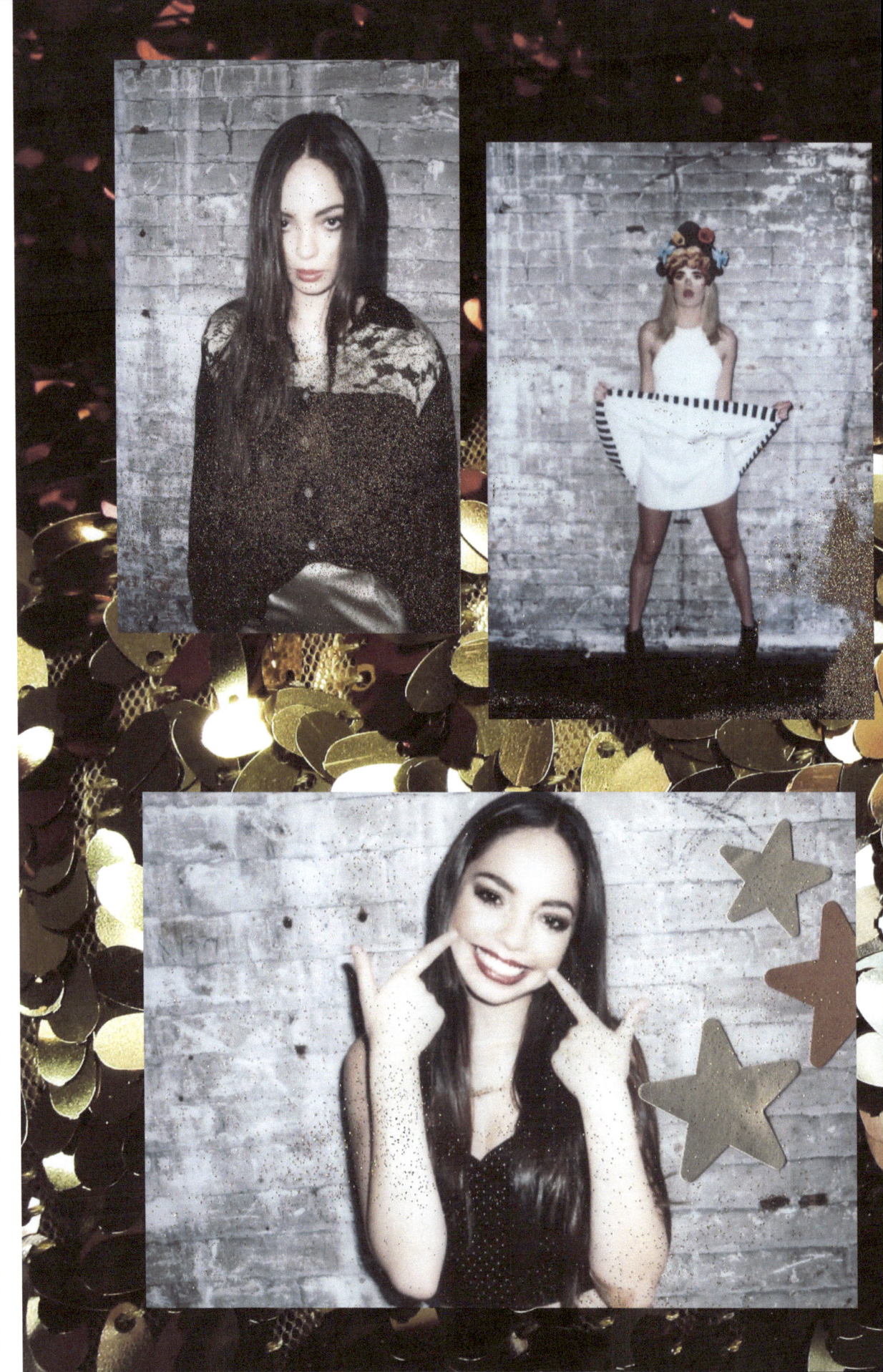

Where did you see yourself before life happened?

BY: MARISSA HOGAN

Think back 10 years ago to a time when you knew very little about life and how it actually worked. You held an image in your head of who you thought you would be. Perhaps you thought that by now, you'd be changing the world daily with innovative, life-impacting work. Or maybe you dreamed you'd be rich and famous in a big city where everyone knew your name.

For many people, a "dream job" is reminiscent of childhood ambitions—a job where they feel like their talents are utilized and they're making a profound impact. A survey conducted by Harris Interactive revealed that four out of five U.S. workers are not currently working in their dream jobs. This high percentage of buried dreams poses the question: where did you see yourself before life happened, and are you content with where you are in life? If 84 percent of the U.S. population isn't working their dream job, maybe it's not really about where you are in life or where you work, but how you view it all.

Take **Carl Scogland**, a 26-year-old software engineer. By day, Scogland creates products that simplify other people's lives; by night, he's a guitarist strumming for audiences. Scogland never imagined that he'd have dual careers, but he does believe he has the best of both worlds. "I've been a dreamer all my life, but my childhood dreams have never changed. I'm still pushing myself to be who I set out to be a long time ago," he says. "I've loved computers since I was like, 10 years old, but I still have big dreams of being a successful musician. I aspired to be a lot of different things early on in life." →

With a college degree, a secure job, albums on iTunes and Spotify, and another record slated for release in January, Scogland seems to be living his dream life—but he feels he still has more to achieve. Scogland, who has been playing music since he can remember, holds on to his major childhood aspiration. "[It's] not stemming from some ungrateful attitude," he says of his dreams. "I just believe that true success is something you don't achieve until old age, when you look back upon your life and know that you lived it to the fullest. 10 years ago, I saw myself as being successful on stage playing music in front of thousands. I'm still shooting for that dream, and haven't given up."

Unlike Scogland, who always saw himself pursuing music, **Teri Wyble**, a 28-year-old actress who graduated from the University of Lafayette with a degree in dance, never dreamed she would be where she is today. "10 years ago, I had no idea what I wanted to 'be,'" admits Wyble. "Though I did have hopes of moving to a bigger city and modeling full-time."

Wyble modified her ambitions because she wanted to be closer to family, and the New Orleans market for a successful full-time modeling career was nonexistent. While Wyble adjusted her goals to have the best of both worlds, she doesn't believe she sold out on her dreams. "I wouldn't rather be doing anything else. I think most people would call that a passion," she explains.

But getting where you want to be and pursuing a life passion doesn't come without its struggles and waves of monotony. Wyble spends 12-16 hour days on set and works as a go-go dancer, television show host, and model to support herself financially between acting gigs. "I always knew I would be in the arts, in some way, shape, or form. Luckily, I now have many jobs that satisfy all of those artistic loves," she says. "I'm a big believer in doing what you love, even if that means being a broke artist for most of your life. I wouldn't be in this industry if I didn't love it. I don't see how anyone could be! It's a tough career."

Wyble strives for better career opportunities, but she is happy with where life has taken her, and remains open to all of the possibilities life might offer. "I'm grateful for all of my successes, big and small, inside and outside of my career," she says. "Happiness is a choice. You control your life. No one else. 10 years from now, I simply hope to be happy. That's all. I don't care what I'm doing or if it's different from what I'm doing now. I just hope that I'm alive, and well, and happy."

Like Wyble, **Joseph Murphy,** a 25-year-old engineer living a simple life and searching for his true calling in his spare time, is looking to the future without self-imposed pressure. Over the past 10 years, life has thrown a lot of obstacles in Murphy's way, and he expects more of the unexpected. "I'm still trying to figure out what the right path is, or even if there's any value in the effort of figuring out a right path," says Murphy. "I think we often find ourselves making plans and paths, [and] as time progresses, reality shoots so many curveballs and blind-siders that our little Pollyanna-ish plans miss the mark." Instead of making a detailed checklist and beating himself up for missing an item, Murphy focuses on remaining enthusiastic about opportunity as it arises.

Murphy also believes the perfect career isn't always about passion or childhood ambitions, and disagrees with self-help advisors who urge clients to throw caution to the winds as they follow their dreams. "I would never suggest that a person should stick [in] a job that they hate, but I don't think just because you love gardening, you should quit a stable job to become a landscaper," he explains. "It is not practical for every person to be a professional football player or a mayor. One needs to recognize one's passions and interests, and find ways to fulfill them. A job can be the means to providing the resources in order to have your passions." While Murphy isn't passionate about his work, he loves to travel, and his job allows him the flexibility and resources to fulfill that passion.

Scogland, Wyble, and Murphy's stories remind young professionals everywhere that whether we are or ever become Grammy-nominated musicians, major motion picture actors, or lifesaving doctors and firefighters, life is continuously changing. The places we imagined we would be 10 years ago have transformed since then—just like the future will turn out differently than we imagine it right now. But if we are learning, living, and growing, we will understand that this change is one of the best qualities of life. It allows for possibility, and the hope that one day, we can all pursue our dream jobs and create successful lives for ourselves, no matter our occupation.

Ephemeral Moments

FEATURING SAWDUST INSTALLATIONS
AND PHOTOGRAPHY BY:
AZU ROMÁ

Azu Romá is an artist and designer, born to Guatemalan parents, and proud to be creating in her hometown of New Orleans. Romá's artwork is a blend of maintaining and reinventing traditional folk art. This series consists of time-sensitive explorations that incorporate bold and colorful typography created from sawdust.

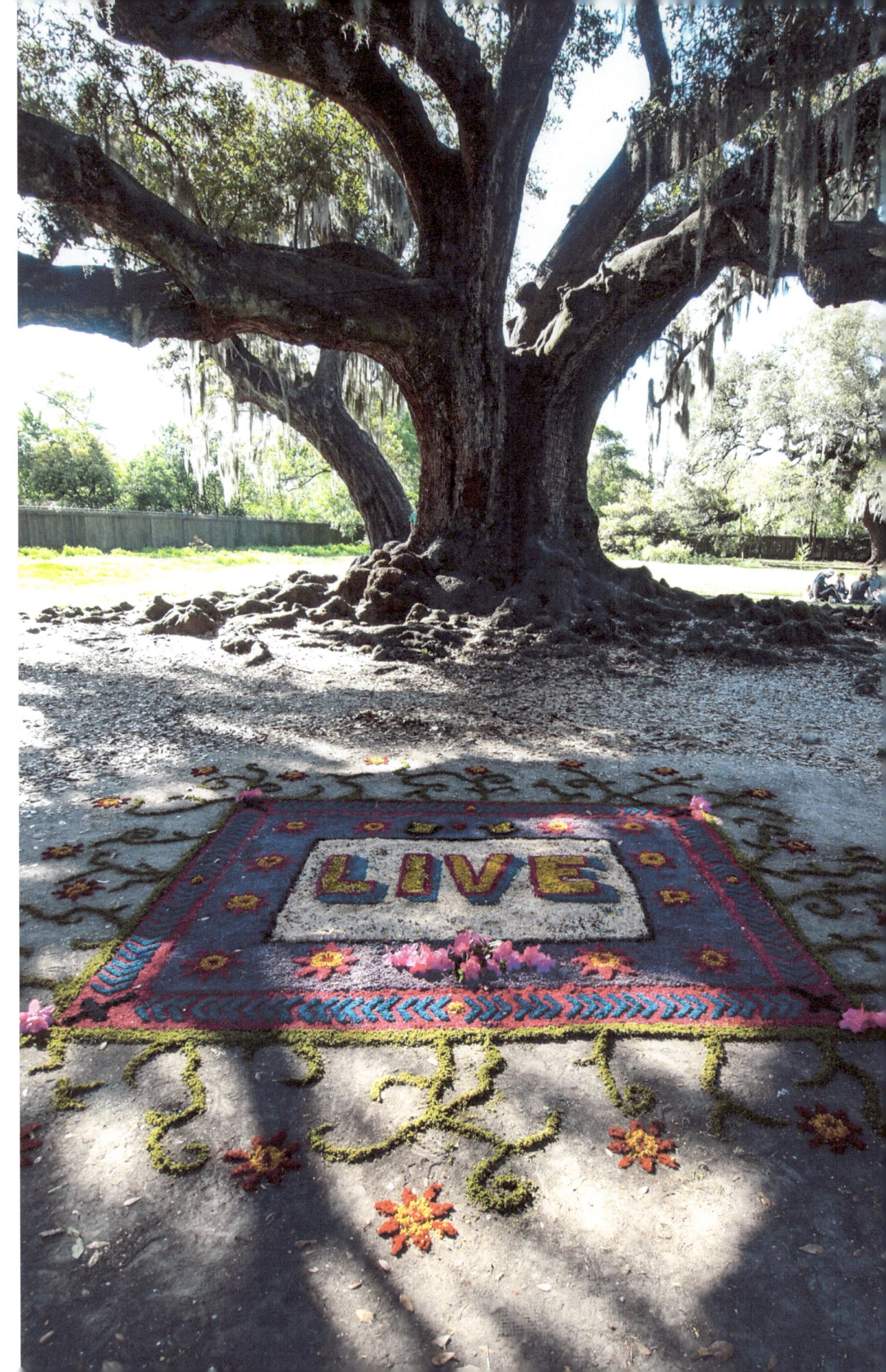

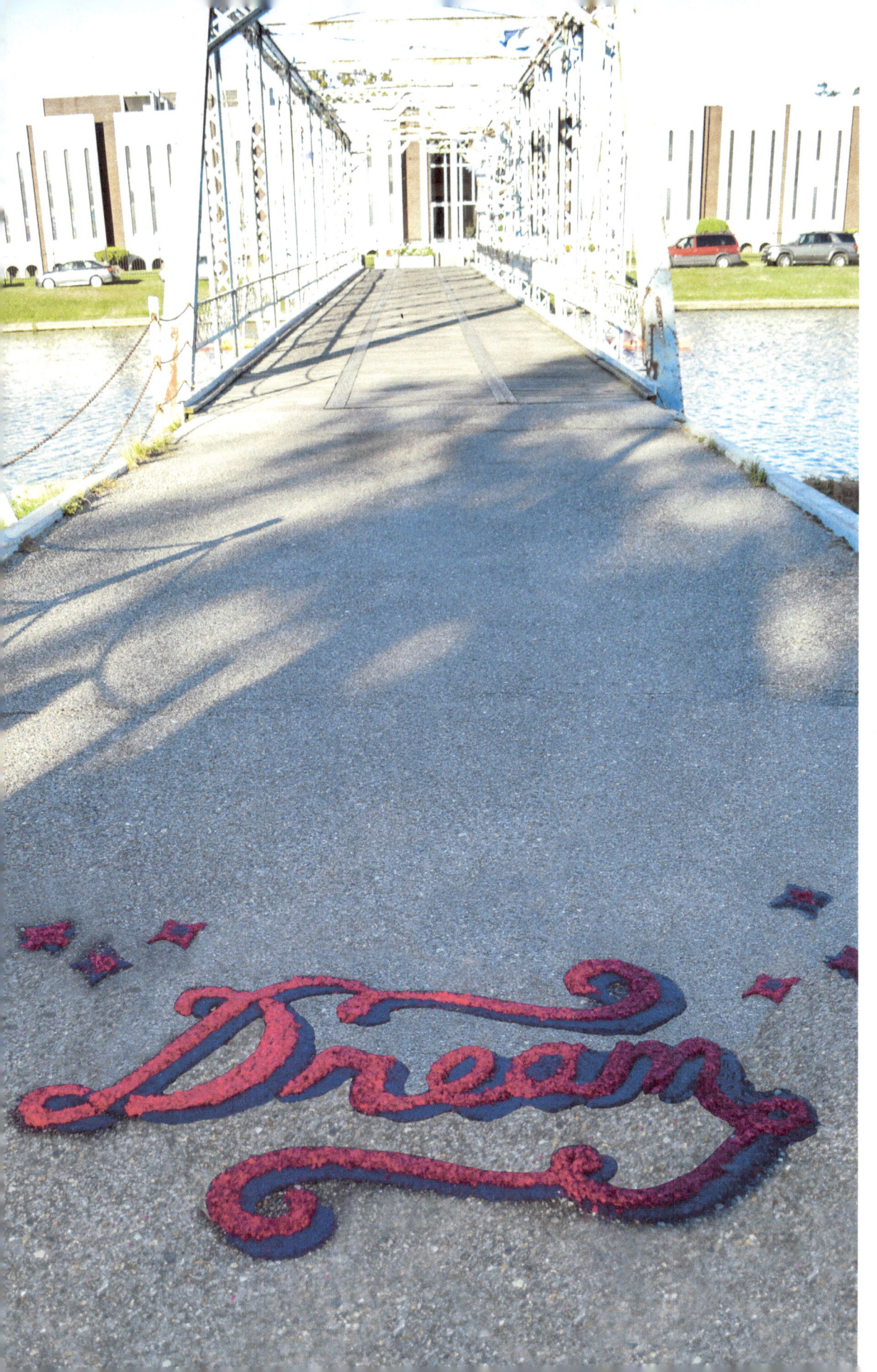

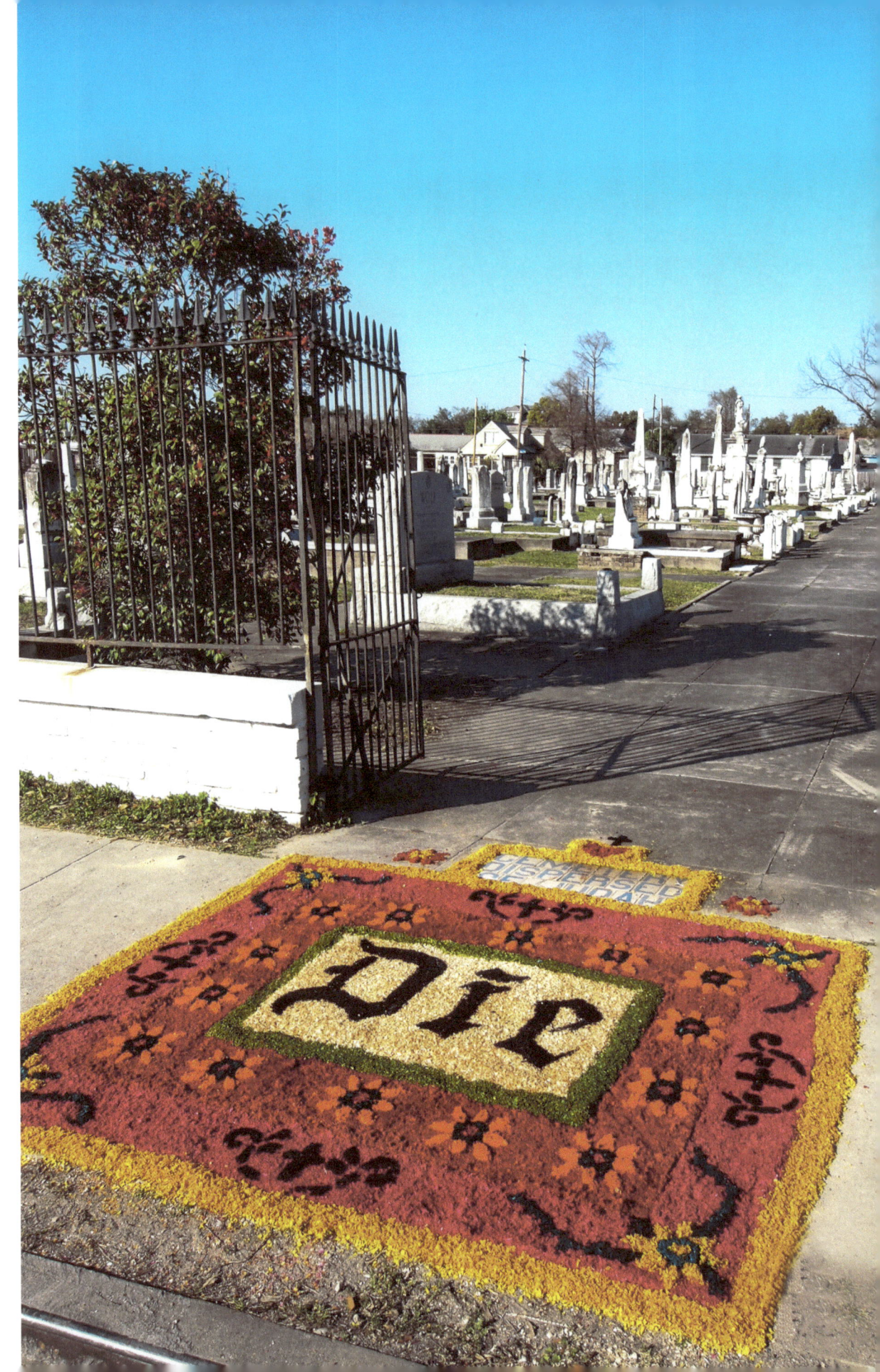